The Pier

A FISHERMAN'S STORY

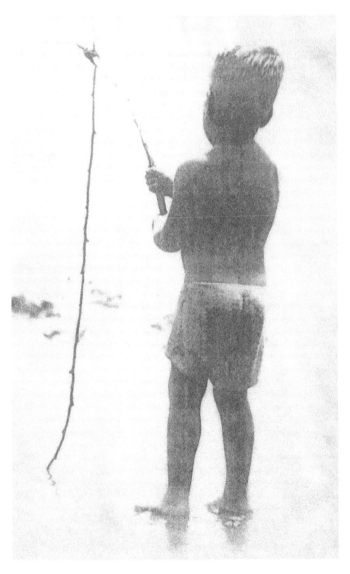

The Author learning the art and patience of fishing.

TIMOTHY JAMES BOTTOMS

The Pier

A FISHERMAN'S STORY

The adventures of a young boy
who spends the day on a pier.

TALL TALES PRESS

– 2 0 2 3 –

ISBN 978-0-578-27133-0

First Edition

PRINTED IN THE
UNITED STATES OF AMERICA

BOOK DESIGN BY
JOHN BALKWILL, LUMINO PRESS

DEDICATION

This story is dedicated to my grandfather who taught me the art and patience of fishing; to his son—my father—who after the death of my grandpa continued to share his knowledge and love of the sport and the ocean with me; and to my mother who gave me permission and trusted me enough at eight years old to spend the entire day alone on the pier.

This story is for my sons, Bartholomew, William, and Benton, and my daughter Bridget. I want to share with them my memories of fishing friends and tall tales when I was a kid on the pier.

INTRODUCTION

THIS IS MY STORY. Some of it happened and some of it only in my imagination. Tall tales fishing stories of the ones that got away and the ones I landed. It is many experiences over several years taking place all in one day. One glorious beautiful day.

Not that long ago, I was eight years old and the pier was my most favorite place in the whole world, or at least all of the world I knew. The pier left the pavement where it met the boulevard and on pilings and timbers rose above the sand and over the waves out to the horizon, ending at the breakwater and harbor mouth. There I would sit fishing and watching the boats and seabirds in flocks and in pairs come and go.

The pier has changed over the years. The quantity and species of fish have changed or have simply disappeared. The old buildings, some destroyed by fires, others simply no longer able to stay in business, have changed. Familiar faces and characters are all gone now. But the pier remains, and the memories flood over me, of days of innocence and youth. That and the great Pacific Ocean.

I return there for walks to think about life's endless changes. Sitting at the end of the pier looking down into the water at life clinging to the pilings, I

see the flash of fins and tails of fish. I see my reflection far below. My hair is gray and, as I stare at my face undulating on the surface of the ocean, old memories shroud around me. I remind myself of those older fishermen in my yesterdays who waited patiently for that one big fish.

I catch the flash of a distant memory as a boy again. And so, a story to tell ...

PROLOGUE

MY FIRST FISHING memories involve my hands and those of my grandfather. Gently, his hands cradled mine, reaching through the rail, teaching me to lower a hand-line, sinker, and baited hook, slowly, descending from the edge of the pier and down into the clear water. The sensation of nibbles and the final tug of the unseen fish pulling the line taut. Slowly reversing the process until the shiny, wiggling fish was brought over the rail, flopping on the timbered deck of the pier. A shiner, a small silver and yellow-specked perch.

My first fish. My hand on the little fish, which then seemed so huge and beautiful. The laughter and excitement of the catch, removing the hook, and holding the fish. The cool feel of its scales and satin touch of its fins. The mystery of its ability to live and breathe under the sea. In my eyes, fish flew through the sea like birds in the sky, and this was wondrous and magical.

Letting it go, dropping the little shining perch back into the sea, back into a world that will forever fascinate me.

The Pier

A FISHERMAN'S STORY

– 1959 –

An Old California Coastal Town

T HE OLD PLYMOUTH STATION WAGON pulled up to the curb. The fog was so wet that the windshield wipers were slapping the glass. I was eight years old. I was excited about spending the entire day on the pier. Sitting in the back seat, surrounded by large bags of soiled laundry, I had to climb on top to see through the windows, but they were pretty much steamed up from all the heat in the car. My mom drove while entertaining my little brothers who were on the floor or crawling around the seat beside her.

When the car stopped my mother put her right arm out to keep my little brothers from sliding off the seat and into the dashboard. I slipped down between several bags but stood quickly, my heart pounding. Silence. The fog horn on the pier and the breakwater bellowed several seconds apart.

My little brother's eyes bulged. "What's that?"

We all stared out the windows at the entrance to the pier. Thick, wet fog surrounded the car. Mom put

it in neutral and smiled at me in the rearview mirror.

"Have fun, be careful, and don't go under the pier." She opened her purse, removed some lipstick and started to smooth it on her lips, all the time watching me in the rearview mirror. I started to gather my gear and opened the door.

Joe jumped up and turned around. "I wanna go! I wanna go fishing, too!" My mother had to grab him by the seat of his pants or he would have fallen out the door.

"Don't worry, Mom," I said. She gently pulled Joe toward her and placed him back in the seat beside her.

She had her hands full with us boys. Joe was five and Sam was three, and I think it was a relief to have me doing something today. Anyway, she gave me permission to spend the day on the pier fishing. She would be down the street at the laundry where she would start the clothes, and then take Joe and Sam to the public little kids pool across the street. The big

pool was next door: "The Plunge" we called it. On hot summer days this was the place to cool off with friends. Mom could see the pier from there, and I could see the pool from the harbor side of the pier. I was 8, and she was my mom, so it was good to see where she was. I could tell she was worried.

"Don't worry, Mom. I'll be fine!" She had only two hands, and three monkeys for sons was a lot for any mom.

"Did you pack a lunch?"

"In my tackle box, Mom."

"I'll be right down at the laundry if you need me, at the pool if the sun comes out."

"OK, Mom."

"We'll meet you here after Dad finishes work."

"What time is that, Mom?"

"About 5, 5:30."

I opened the door. "Can I have a quarter for the popcorn man?"

"I wanna quarter, I wanna quarter too, Mom!" Joe had a big voice and could be very loud when he wanted his way. She put something in his hand which went straight into his mouth and shut him up. Sam was quiet and just watched. She opened her purse, found a quarter and put it in my hand.

"Thanks, Mom. Bye, Mom." I was out the door and turned to gather my pole and tackle box.

"I love you," she said. "I mean it. Don't go under the pier. And stay away from those bums."

Putting the coin in my jeans, I waved goodbye. I stood there in the early morning fog and watched as she drove down the palm-lined boulevard, splashing puddles in the street. Slowly, the back of the Plymouth disappeared in a wisp of fog.

I was glad my sweatshirt had a hood because the fog was so thick it felt almost like rain. The call of the gulls, the distant moan of the fog horn, and the smells excited and called to me.

As I slowly started to walk from the sidewalk out onto the pier, glancing down to my sneakers I noticed one of my laces was undone, so I kneeled and started to tie it. Voices from a grove of palms caught my attention. Finishing the bow, I stood and began my walk up the pier. The constant drip of moisture off the palms made an eerie sound as I got closer. Cardboard and empty bottles were strewn on the ground. The smell of tobacco mixed with wood smoke and the faint tones of a harmonica drifted over to me.

A dark opening into the grove grotto had a well-worn path, but I didn't dare go any further, at least not alone. This was where the "bums"—homeless men—lived.

Years earlier my father had carried me on his shoulders through the "Hobo Village" near the slough. I remember the jingle of change in his pocket as he offered coins to the old fellas who needed a handout. It was just down the beach a mile or two, a

small town of men who rode the rails. Most of these gentlemen were kind but once drunk could be unpredictable. That's when the murmur of conversation grew loud and the music stopped. I was warned to stay away from these people and quickened my pace towards the pier. But the fog was so soupy, I soon became disoriented.

I could hear a motor approaching, and the sound of wheels on the groaning wooden planks as a truck came into view out of the mist. I could feel the thumping vibration from the weight of its load. Jumping up onto the sidewalk as the big truck passed, I felt a shower of saltwater and sardine spray wash over me like a wave—a truck filled with boxes of sardines. Seagulls flew overhead and some even landed on the truck, pecking and trying to pull fish from the load.

The last big bump threw a few fish as the truck stopped before crossing the boulevard. Dropping my gear before the gulls could swoop down I dove into a puddle in the middle of the street grabbing at the sardines. Sardines are beautiful fish with forked tails, silver scales and blue spots. Each fish was about eight inches long and fat. I had fish in my hands before I even put a hook in the water. I laughed at my good fortune. With this prize in my hand now, I had bait for my day of fishing.

This was my lucky day, and I just knew the luck was with me. Problem was, I was sitting in water try-

ing to hold three slippery sardines when this big old gull landed just outside the ring of water I was sitting in. He looked me over and walked slowly around me just waiting for me to foul up and drop one. Gulls circled above my head as the truck jammed gears and drove on, taillights fading into the fog.

Slowly, with one eye on the gull and one eye on the prize in my hands, I tried to stand. One slipped from my grasp, and that old gull was on it and into the air in a wink. He looked over his wing at me, adjusted his tail feathers, and was gone into the mist. Well, I was wet but I still had two fish. Yes, this was my lucky day, and I knew I was going to catch something big.

I turned to gather my fishing gear when a large man stepped from the palms.

"I'll take those, sonny."

I stood frozen, scared. This man was huge with a big gray beard, long hair and a brown, stained coat that covered his body. He was wearing a big floppy hat and spoke with the butt of a cigar in the corner of his mouth. The large man was swaying back and forth as he spoke.

"Sonny, this is my spot, and I've been waitin' for that truck to hit that bump to get those fish. They goin' on my grill, so hand 'em over, sonny."

I was petrified. The man wasn't mean, he was just so big and smelly. I slowly held the two sardines up to him. His giant hands took the fish from me, and only

then did the sardines seem small.

"Thank you, sonny. Good luck. And if you catch any fish you don't want, I'll take 'em." I stood still, as the man turned and bent down under the palm fronds, returning to his camp. Sounds of laughter, harmonica music, the crackle of a fire, and he was gone.

I was sopping wet and smelled like fish and had not even stepped onto the pier yet. I just shook my head thinking how fast things changed. I quickly grabbed my gear and as fast as I could, ran towards the pier into the fog. When I was a safe distance from the street, I stopped. My heart was pounding, and I swallowed to catch my breath. I heard the sound of the water on the shore and, moving to the edge, peered over the rail. I was at that point over the sand where the sea meets the shore. The sea was calm, and my fear disappeared as quickly as it had come. This would be a good day for fishing—no swells to cloud the water.

I started to walk faster, periodically looking over the edge into the ocean. I heard laughter ahead but the misty fog was still soupy, so I slowed my pace. These were the halibut fishermen. They sat in their folding chairs with their poles on holders screwed into the top of the guard rail. These men had dark, weathered skin and rolled their cigarettes. Their tackle was light, with spinning reels. One man had his pole in his hand and was jigging up and down, and when his pole bent, he would reel it in with several

small mackerel or herring on his line. I stopped to watch as one of the men hoisted on a rope tied to the rail. On the end was a live bait bucket.

The little fish were put in the bucket—all but one, and that one was put on a hook with a sliding sinker and a swivel and a bobber, then cast out very gently, an underhand cast, so as not to lose the live bait. I moved closer to the old men. They noticed me but didn't acknowledge my presence. The man with the small jigging pole inspected his gear. There were six small hooks with red yarn and a little feather. At the end was a shiny sinker with a treble hook. The man had on a long-sleeved shirt, khaki jacket and a khaki small-brimmed hat. He kept his cigarette in his mouth the whole time, even when he talked to his friends.

As he inspected the hooks, I blurted out, "What is that called, mister?"

Without looking at me, he answered, "That's my Lucky Joe, sonny boy," as he wiped his hands clean on the towel that hung on the rail.

"Where can I get one of those Lucky Joes, mister?" I asked.

"The bait and tackle shop," he said, pointing toward the finger of the pier, still hidden in the fog. "All the best fishing poles and tackle can be bought there."

He then went on back to his pole, picked it up and lowered his line back into the water, jigging. On the larger pole, another man, dressed almost identical to

the man jigging, snapped a small bell on to the pole with the live bait attached.

"What's the bell for, mister?" I asked, not thinking that I was bothering these older gentlemen.

"That's the dinner bell, sonny," and the three laughed "Run on, kiddo. You're scaring the fish."

I took a few steps up the pier, glancing over and down at the bait bucket that floated on the surface. I could hardly believe my eyes at the size of the two halibut on the line next to the bucket. Big, flat halibut about ten pounds each. They were shades of brown with white bellies.

"Wow, those are huge!" I said. I thought these guys were the best fishermen; they really knew their stuff.

One of the fish was still alive, and I could see its teeth and those two eyes on one side. It flapped its tail trying to dive, but the rope through his gills held him tight. I could only stare at this fish and then at the fishermen and then at the fish, all the time imagining what it would be like to catch such a fish. What a meal that would make; what a fish to remember.

"I said run on, kid. You're scaring the fish," one man snapped.

I didn't run, but I did move on up the pier. I found myself alone in the fog again. My mind was racing with anticipation. What would I catch? What would I see? I was bubbling over with excitement. The day was just beginning and I felt lucky. The Shell ship comes

into view. A replica Spanish treasure Galleon. The ship is placed on blocks on top of the pier deck. There is a gang-plank so that tourists can walk up and into the ship. Her treasure is sea shells from all over the world. As I turn…she slips into the fog and mist.

Wandering up the pier the fog started to break, creating holes of blue sky through the gray. The sun was melting the mist. I could feel the warmth of the sun on my face. Standing still, looking up into the sky and closing my eyes, the smells and sounds filled every sense. I was trying to imagine what I was going to catch.

After seeing the size of those halibut so close to shore, I could hardly imagine the size and species of fish that could be caught off the end of the pier. I couldn't wait to find a spot and get to fishing. I broke into a run.

Suddenly I found myself in sunlight and a cacophony of commotion on the wharf. The sardine conveyor belt was running and sardines were being loaded into the waiting trucks. Dozens of seagulls laughed and called, with the occasional crow cawing. Commercial boats below were tied to the pier while others circled outside waiting their turn to unload. Fishermen were hoisting fish from a hold in the deck, big nets full of sardines. The fishermen were dressed in big rubber boots and rain gear. The sound of the conveyor and hoists, men laughing and barking at each other, drew me closer.

The captain, high above the cabin and deck, stood with his back to the wheel, his long sleeves rolled up. He was keeping a very sharp eye on the men below and the unloading of his catch. I needed bait so I found a place to stand where I was in shadow and out of the way. I put my tackle box and pole up against a building and moved closer where I could get a better look. The smell of fish and diesel was intoxicating. Looking under the truck and under the conveyor from where I now stood, I had a good view of where fish fell from the loads. Several sardines had fallen but almost as soon as they fell, seagulls would dart in and snap them up. I was going to have to be quick if I was going to grab a fish before a gull could get it.

I prepared myself and was ready to dart in as soon as a fish fell off the truck or the conveyor. But just as a fish fell and, unseen to me, I felt a hand on my shoulder.

"What do you think you're doing, kid? You want to get squished?"

I looked up into the eyes of the driver of the truck. He, too, spoke with a cigarette in his mouth. He, too, had on a long sleeve shirt, but was wearing suspenders and had a big stomach.

"I just need bait, mister." As I spoke a gull grabbed my fish and took to flight.

"Get out of here, you little wharf rat! I can't have you kids around this hoist. Now run on."

I ran to my pole and tackle box, stepping out of the shadows and into the light. The gull with the sardine flew up, only to be attacked by other gulls wanting his catch. As he tried to protect his catch, but was unable to swallow the fish, it fell from his mouth and hit the pier just in front of me. I was on it in a flash, and the other gulls were on me just as quick, but the fish was in my hand, and I was not giving it up to any old gull. Now I had bait, and I felt that luck was with me for sure.

From behind me I heard my name. "Hey, Tim, the bonito are biting!" It was my friend Jose. He was stopped behind me on his bike. He snapped his fingers and gave me a thumbs up. I snapped as best I could and returned the sign.

"All right! We better get out of the way. These trucks are paid by the load, and we don't want to get squished," he said laughingly. Jose always had a laugh in his voice. He was pretty happy. He was older than me, but he was always kind and helpful. He had his casting rod tied to his bike and his tackle box on the back.

We moved out of the traffic and kept moving towards the end of the pier. The morning was full of activity and other kids were already fishing. The diner was serving breakfast, and fishermen had left their gear outside the door. Fishermen with poles and tackle boxes hurried past.

"You have a lure, Tim?"

"I think so."

"You need a shiny sinker with a treble hook. That way you can cast it out where the bonito are. Look for the boils, and then cast into it and get set." He laughed. "Hey, the boats are loading at the landing. Want to watch 'em leave?"

"Yeah, sure" I said.

"I'll save you a spot." He hopped on his bike and raced off to the landing area.

I hurried along as best I could with my sardine in one hand and my pole and tackle box in the other. Barely stopping to put the fish in the pouch of my sweatshirt so I could even my load, I resumed my run to the landing.

When I got to the landing, there was so much excitement. The crowd of men were all lined up waiting at the gang plank. They were all talking, their fishing licenses attached to their hats or shirts with all their gear and rolled up gunny sacks. They had bought their tickets for the half- or three-quarter day sport fishing boats. The all-day boat left at four in the morning and by now was already off the islands. These boats came

over from the harbor, took on passengers and then went out to sea from the pier.

"They're biting at Camby's Reef," I heard one man say as I made my way through the crowd. "Caught a 30-pound yellowtail yesterday."

"Who won the jackpot?" another man asked.

"Hey Tim ... over here." It was Jose. He had found a spot where we could watch everything, and when the boats left we could have a good chance at catching a bonito. The first boat came around the end of the wharf, and over the loud speaker we heard, "Half-day boat, half-day boat. Have your tickets ready!"

As the vessel came around, the captain roared the engines into reverse, the boat pulled up to the pier, and lines were tossed to the large cleats.

"Stand back, please!"

Kids who were fishing pulled in their lines quickly so they wouldn't get tangled or cut by the big boat. Standing on top of the bait tank in the back of the boat was the bait boy, about 16. He had on rubber boots and the same long-sleeved Pendleton shirt all the fishermen wore.

"Throw us some bait, mister!" some of the kids yelled from the pier, and the bait boy just laughed at them.

"What are you catching?" another kid yelled." The bait boy answered, "Boneheads and berries."

"Oh yeah!" said Jose. "Boneheads and berries, boneheads and berries!" We yelled in unison. That

really made Jose laugh. I was swept up in the laughter and yelling, and laughed and screamed with all the rest.

The captain of the half-day boat got on the loudspeaker: "Stay clear until the ramp is lowered."

All the fishermen with half-day passes crowded in on the entrance to the gangplank. As soon as the plank was lowered, they hurried to get themselves in a position on the boat, quickly unrolling the gunny sacks and hooking them onto the inside rail or onto the edge of the big live-bait tank in the center of the ship. All these fishermen were very serious, and quickly set to getting their gear ready.

Someday, I too, would go out on a half-day boat. *Wow, what a day that would be*, I thought to myself.

"Stand clear, cast off!" The boat was off as quickly as it arrived. Lines were thrown from the pier.

Jose yelled at the bait boy standing on the bait tank, "Throw us some bait!"

He dipped a net in the tank and threw anchovies up onto the pier. Kids scrambled to gather the wiggling anchovies, quickly putting them on hooks and lowering them into the water, keeping them alive.

As soon as the boat was away and the sea calmed, they would be cast out into the ocean, live bait on bobbers, waiting for the strike of a bonito or barracuda that were just below the surface. Jose laughed and whistled. The bait boy threw another net full high into the air, the fish landing into the sea and the wake

of the boat as it powered away. The powerful motor churned the blue-green sea white with foam, and the black diesel smoke from the stack billowed into the air. All the while, the gulls overhead dove into the wake to catch the bait that had been dumped.

"Adios, buena suerte!" Jose yelled.

"Adios!" I yelled, and we waved to the departing fishermen and the bait boy. Some of the fishermen waved back to the crowd of kids on the pier.

As soon as the boat was out of range, fishing lines were cast into the ocean. "Hook up!" Looking up the pier, I saw a long pole bending with the taut line cutting through the water. "Hook up, hook up. Make room!"

Coming down the rail was an older kid, and the drag on his reel was singing. I could see the silver-bullet shape race through the clear water. Fishermen either reeled their lines in or moved away to give the kid room. Several tourists crowded in to watch the excitement. This confusion caused a line with a fish to tangle with other lines, and soon several poles were hooked to one fish. The young man safely avoided this tangle by holding his pole high over the heads of those in the mess and distancing himself. Tightening his drag, he started to crank hard, but the fish was not about to surrender.

"Hook up!" another person yelled, this time from beyond the gate where the abalone processing plant was.

For a dollar you could buy a ticket to the end of the pier and fish the railing around the building. All the guts from the abalones were dropped into the sea under the wharf where the fish there numbered in the thousands—every kind of fish you could imagine.

"Don't horse him in, kid, or you'll lose him," said an old man who was just putting his gear down.

The old man opened his fold-out chair and sat down, smoking a cigarette, and started tying a swivel on a line. The kid's face was grimacing when "Snap!" His pole went stiff, and the silver fish disappeared out into the blue. The line slipped from the surface and followed the free fish until it was gone. The expression on that kid's face when his line snapped will be forever in my memory.

"Holy cow! What happened?" he said as the pain of the loss hit him.

Finishing his knot without looking up from his work, the man said, "You got to fight him son, you got to use your drag and wear him out."

"Did you see him … did anyone see him?" the kid asked. Everyone just shook their heads slowly, and a quiet fell on us all.

Up the pier, beyond the gate, they were still cheering the fisherman on. "Get a gaff! "It's a big berry!" I heard.

I jumped up on one of the big cleats, and balanced myself by holding a stanchion to a flag pole to get a better look at the people bending over the rail, and

saw the fish hoisted up and over. It was a big barra-cuda, about 30 inches long. The kid who lost the fish just stared out to sea, then hung his head and made his way back to his spot to try again.

I climbed down and opened my tackle box. I could not wait to get my line in the water. There wasn't much in my box: a few sinkers and hooks, a tangle of trout lures, an old knife, and my old hand line, and what was supposed to be my lunch—a pea-nut butter sandwich. My pole was small with a button spinning reel loaded with a 12-pound test line.

Without thinking—something eight-year-olds are famous for—I had put the sardine in my pouch and had forgotten where it was, so I panicked when I couldn't find it. But it was right in my pocket, where I had put it, so I went to cutting bait.

Jose looked at me and said, "This is a good spot for you. I have a shinny sinker, so I'm going to go up the pier where I have more room to cast. But you stay here. This is a good place for you. I see you later. . . watch my bike, ok?"

"Sure," I said. Jose ran up to the area near the gate where there seemed to always be excitement.

I found the end of my line and slowly started pulling it through the eyes on the pole. When that was completed, I tied a sinker on the end. I just kept tying it on until it was snug. I used the same knot that I tied my sneakers with except I didn't make the bow. About a foot above that, I attached in the same fash-

ion as the sinker, a hook with about a foot of leader. It was a pre-tied hook that came in a packet of six.

All the while I would glance over to my left and right to see what the other fishermen were doing, what they were using and what they were catching. The old man who gave advice to the kid who lost the big fish sat in his chair smoking his cigarette. He had one beautiful pole with a spinning reel. He looked a lot like the halibut fishermen at the beginning of the wharf I had seen earlier in the morning. He was dressed pretty much the same and had the same gear. When he caught my eye, he just smiled and went to staring out to sea. I looked out too. Several boats were anchored off about two hundred yards from the pier—sailboats, and motor boats of all shapes and sizes.

An enclosed floating pen held seals that were captured and kept there until they were sold to circuses and zoos around the world. I knew this because I asked once. I was told they were made into seal burgers and this bothered me to no end, so I asked my dad and he told me the truth.

Beyond the anchorage lay the estuary and the shanty town refuge.

My attention now back to fishing, I decided to have a look into the ocean in front of me. Moving on my hands and knees as close to the edge as I dared, I gazed down and into the sea. Fish darted here and there. Pilings fat with mollusks and kelp made a won-

derland that I could stare at literally for hours. But big fish had been caught and lost right in front of me, and I knew today was the day, a day to be remembered. I set to getting my line in the water.

I took a small piece of the sardine and put it on my hook, then positioned myself on the edge of the pier. Holding my pole out over the water, my legs dangling, I pushed the button and watched my sinker and bait drop between my shoes into the sea. I heard the splash of my sinker and waited until the line went slack—that meant I was on the bottom. Then, I reeled the line in until it was taut and just off the bottom; any second now, a strike and a fish would be on.

I was pretty proud of myself, I must say. Tying on my own hook and baiting it up myself. I was fishing. I was a fisherman. I looked over at the old man in the chair and caught his eye. I gave him that kind of look of one who knows what he's doing, and the old man looked at me with that *you know what you're doing* response. This communication between fishermen was unspoken, and I knew then I was among sportsmen.

I felt a nibble, and my focus went to the tip of my pole. Another nibble, and my imagination was telling me that a big bonito or a big halibut was playing with my bait. I was ready to set the hook as soon as I thought the fish was on. All my attention was on the tip of my rod, and all the world around me went out of focus and silent.

The three-quarter day boat was coming in now

to pick up the last of the waiting fishermen, but I didn't hear it. The nibbles continued, and I was mesmerized by the sensation and completely absorbed in the moment.

"Better bring it up, son, or it'll tangle in the piling." The voice of the old man was soft and slow and very calm, and it gently brought me out of my excited hypnotic state. I looked up at his face. He was just sitting back, his eyes closed as he basked in the warmth of the sun on a summer morning.

"What's that, mister?"

Without opening an eye or moving an inch, he said, "The back wash will push your gear into the pilings. Better reel it in."

Only then did all the sounds and commotion of motors, loud voices, and the endless laughter of the gulls come into my ears. The big boat came about very quickly. The high bow making a wave that rolled under the pier. The big motors roared as the prop was put in reverse. The current fanned out 50 feet from the stern, clouding the clarity of the ocean with foam. I was cranking as fast as I could when my line went taut and the little pole tip bent over and down. The boat's wash hitting my line gave me the sensation of what I imagined to be a very big fish. Down, down, down, the pole was going wild.

"I got a big one, mister! I got a big one!" I was so excited. What kind of fish was it? I could hardly wait. I tried to look over the edge to see, but the chop

blurred my view of the usually clear water.

I had a big one on, and all I could do was hang on to my pole. I stopped cranking my reel and just tried to keep my tip up. The big motors were in neutral now, and the frothing slowed and finally stopped. And so did the fight in my pole. The fish must be tiring, I thought. Now I could get a look. With one hand on the rail and the other on my pole, I peered over the side and down into the water. The clear water had returned, and I could look down into the sea. The glare from the morning sun on the water made me squint, but I could see the pilings full of mussels. I followed my line down and into the sea; it went down at an angle under the pier. I could see tangles of line from other fishermen who had lost their gear. Sinkers and hooks hung everywhere.

My pole was very still now, so I set it down and lay prone, looking down and under the pier into the mysterious darkness. Shafts of light from the cracks between the planks gave me a view of an awesome and wonder-filled world. I could hear the sounds of pigeons in their nest below, and then suddenly the slapping of wings as a bird flew under me and out into the light. I reacted with a start, and my concentration broke, but I had to know where my line was.

On the surface, schools of smelt circled just outside the pilings, only darting into the safety under the pier when a larger fish would cruise by. Suddenly a large perch came into view. The fish was concentrat-

ing on the pilings as it floated up and down the mol-
lusk-filled wood post. Still I could not see the end of
my line or the giant mystery fish on my hook.

"Hey, Tim, look what I caught!" Jose was standing
behind me.

I was on my belly looking up and back over my
shoulder. The sun was on his face, and the smile he
had on was as big as a smile could be. His pole was in
one hand, and a beautiful shining silver fish dangled
from the other.

"A bonito!"

I was so excited, I completely forgot about my line
and jumped to my feet. The fish was still very much
alive. Jose held the line, and the treble hook on the
shiny sinker was still hooked in its mouth. The fish
shook, and the sunlight on its skin made it shine and
shimmer. Jose laid it on the wharf, and we got down
on our hands and knees to examine this beautiful
fish. On closer inspection, the blue and green stripes
seemed to change color as the dying bonito now lay
still on the wood planks. It was about 14 inches long
and weighed around two pounds.

"Holy smoke," was all I could say.

"I saw the boil … I did an overhand cast … and
hook up!"

"Did it fight hard?" I asked.

"Oh yeah … it went up the pier … then down the
pier … but I got him!"

We just stared and watched as the life left the

fish, and with it so did its brilliant colors. Now still, it had turned to a dull pewter gray. It was a mystery to me how the color and life force of a fish faded when it died.

The three-quarter day boat had loaded its passengers. The captain was on the loud speaker. "Cast off all lines. We'll be fishing off Naples Reef today. Lots of yellowtail, folks, so get set. Johnny will be taking a jackpot for biggest fish, so if you want in, put your dollar in the can."

The big motors came to life, but we just stared at the bonito.

As the boat pulled away, we heard, "We have a full galley, hamburgers, beer and soda …." The loud speaker crackled and faded with the engines, then the sea went flat and became clear again.

The old man in the chair was now putting tackle on his pole and without breaking his concentration said, "Better clean it before it goes bad."

Jose quickly put his hand in his pocket, pulled out a small pocket knife, and went to gutting the fish.

"Not here, son. Use the faucet and cleaning table over there. We don't want blood and guts all over the place."

"Oh sure, mister." Jose jumped up and, leaving his pole, ran off to clean his fish.

I was still on my knees and stared after Jose as he disappeared into the people and parked cars. *My fish!* I thought and laid back down on my belly, grabbing

my line. As I pulled it with my hand, I realized it was snagged on the bottom or on a piling, and I didn't really know what to do.

"Ah, nuts," I said. I heard my grandpa use that phrase when he was mad or upset.

As I sat up with the line in my hand, the old man slowly lowered his tackle and said, "That bad, huh?"

I was pretty upset, let alone embarrassed about my predicament. I didn't have that many hooks and sinkers, so losing my set-up upset me.

"Hand me your pole, son. Let me see if I can help."

I gave him my rod, and he reeled the line until it was taut.

"Snagged on a piling … Yep, snagged on a piling." He had one hand on the rod, and with the other he took a few wraps of line. With a quick jerk, the line snapped and he reeled it in.

"I don't wet a line until the sport boats are gone. Let's set you up." he said. "What would you like to catch?"

I never thought about it that way. How could I know what I would catch? Put your bait in the water and hope for a bite.

I thought for a moment and said, "What do you mean, mister?"

"Call me Bill, son."

I looked at Bill and thought hard for a few more seconds. "Oh … a bonito … no … a halibut. I don't know, Bill."

"Well, we use the same bait for a bonehead or a halibut. But one lives on the bottom and the other on the top, so you're going to have to make up your mind."

"What's your favorite fish to catch?" I asked.

"There is only one fish worth catching for me and that's a halibut. Bonito are too greasy and smelly. Besides, if you don't bleed 'em right away, the meat goes dark and is just too strong. Not too bad if you smoke it though. Now, a halibut …."

Bill stopped talking and looked at me. There was silence as we both stared at each other.

"Now what are we going to catch, a halibut or a bonehead? Can't catch nothing if our lines aren't in the water."

I was silent, thinking halibut then bonito, but I couldn't make up my mind, and I could see that Bill needed a decision.

"I want to catch one of each," I said. This made Bill laugh.

"One of each it is. Slide that tackle box of yours over here, and let's see what you got." Bill was a dark-skinned man and clean shaven. He removed his short-brimmed hat. His hair was so short it wasn't even there. I could smell his tobacco. His hands were clean, and his long-sleeved shirt was ironed and so were his pants. His shoes were leather and shined. He sat in his folding chair and pulled out a rag, which he placed on his lap, and then he put my box on his lap.

"Nice tackle box," he said as he pulled some spectacles from his shirt pocket. I beamed when he said that. It was a pretty blue-green box, the color of the sea.

"My mom gave it to me for my birthday," I beamed.

"Now let me see … " he said as he opened my box. "Well … we can use this hook and this weight. You got a bobber, son?"

"No, sir, I only got what's in the box. Do I need one?"

He removed what he needed from my tackle box—no mention about the rat's nest of line and old hooks, or my lunch. He just closed up my box and, smiling, handed it back to me.

"Let me see what I got here." He turned to his tackle box. His was wood with a brass handle, and when he opened the top, the front panel folded out to a table, and there were five drawers. I stood up to get a better look. He slowly opened the bottom drawer where there were hooks and lures, swivels and extra line. Everything was neat and in its place. He had a whole tackle shop in that box. He removed a small red and white bobber.

"Hand me the end of your line, son." I found the line and handed it to Bill.

"Now, I'm going to show you one knot. It's all you really need to know. So take the hook and put this line through the hole there. I'll just get my line in the

water while you do that."

I sat there trying to line up that line with one hand and put it in the hole on the shank of the hook with the other. It was not easy, especially for an eight-year-old, and I guess I got pretty frustrated and must have been making lots of noises because Bill spoke to me as he was baiting up his rig.

"Patience."

He had a small shiny sinker and a leader about two feet long. On the end was a small treble hook, and about six inches above that was a single hook.

I stopped to rest my eyes and asked, "What's that set-up called?" Fishermen had names for all their stuff. "I saw a fella use a Lucky Joe this morning".

"It's a trap. Now you just put that line through that hole, young fella." He took the salted ancho-vy and hooked the tail on the treble, with the single hook through the head. He leaned over in his chair and with a quick underhand cast flicked the bait just out beyond where the boats tied up.

"Patience, son, patience. If you're going to be a fisherman, you need lots of patience."

I went back to my task, and just like that, the line found the hole or the hole found the line.

"I got it! I did it, Bill!"

Bill set his pole in the holder and sat back in his chair. Keeping his attention on his line, he turned to me.

"It's like this …." He took a small rope. "The fox

came out of the hole, jumped over a log then went back down the hole."

"What?"

"Just having a little fun with ya."

He threw the rope and knot aside. This threw me for a loop.

"Ok, now pull about six inches of line through that hook and twist the line about six times."

I set to twisting my line.

"Why do you like halibut?" I asked.

Bill smiled and pulled a small white bag from his shirt and set to rolling a smoke. "Don't you ever start this habit, son."

He twisted up a smoke as fast as he tied the knot in the rope.

"Done," I said.

"Ok, now take the end of the line and put it through the opening before the first twist. Don't let it untwist now."

He struck a match on the sole of his shiny shoes and lit his cigarette. I was having a hard time; my fingers and the line were just not working together.

"Here, I'll help you." He spoke with the cigarette in his lips. His hands slowly helped me guide the end of the line.

"Now see this big hole here?"

I nodded yes.

"You take the end and put it back through and pull it tight." He left a little slack for me to pull, and the knot

pulled tight on the hook. He put the smoke aside, held the line to his mouth, and bit off the tail end.

"Now take that split shot and put it about two feet above your hook."

I lay the line in my lap and placed it in the crack of the small, round lead.

"Here, use these pliers and give it a squeeze."

This was more complicated than I could imagine. There was a lot to this fishing business, but I wanted to be a fisherman, so I put my mind to the task and finally squeezed the lead tight on the line. I now had a hook and a lead on my line. While I was doing this, Bill slowly reeled in the line on his pole. Just a few spins of the handle, and then he let it sit.

"I got it," I said, handing him back his pliers, which he put back in the leather sheath on his belt.

"Take this bobber and push the button on the top. See that?" He demonstrated for me so I could see that by pushing the button on one end, a small hook came out the other side. "Just put your line through that hook and let it close. Put it about two feet above your lead."

So I did that, and now I was ready for bait. I took a piece of the sardine and hooked it on.

"Ok, now you're going to have to cast it out away from the pier. Don't want to lose it again. No, siree. You'll have to do it underhand. Think you can handle it?"

I nodded yes, even though I'd never cast before. I

stood there, pole in hand, and just stared at the bobber, not really sure what to do first. I could handle an underhand cast—I had just never done one before.

I think Bill sensed my dilemma. He got out of his chair, held my hands and helped me without my asking.

"Careful not to get tangled, now. I'm sure you saw all the gear under the pier, right?"

This I remembered, so I let Bill guide the slow swing back, then out and back, then out, and pressing the button on my reel, the bait, lead and bobber sailed out 20 feet from the pier and plopped into the water.

"That's all there is to it." He sat down and took his pole from the holder and started bringing it in very slowly.

Almost immediately my bobber went under the surface and then bobbed back up, then under the water and back to the surface.

Bill laughed. "When that bobber goes under, give your line a yank, sonny."

I didn't know it, but my hook was empty. Bill knew it, but he didn't say anything. My bobber stopped moving. I could see the forms of little fish under my bobber. I started to reel in.

"Just let it sit out there. Patience." Bill needed time to fish, and I was content to just sit there and watch my bobber.

So much was happening. Boats anchored just outside the pier sat still on the water. Not a breeze,

not a cloud.

"Look." Bill pointed to a boil about two hundred yards out near the boats. Anchovies were jumping out of the water and the slashing of fins and splashes broke the surface.

"Bonito," he said very calmly.

There they were, just out of reach. All of a sudden one streaked in close enough for us to get a look. Fast like a torpedo. So fast I saw only the blue-green stripes on its back. It swam right under my bobber, so I yanked my line right out of the water.

"Easy there, big fella."

My heart was in my mouth. I had no bait and my bobber didn't move, but I hooked up anyway, even though it was only in my mind.

"Looks like they stole your bait."

So I reeled in and set to bait up. Boy, was I excited now.

"Bill … why do you like halibut so much?" I still wanted an answer. Bill was reeling in his line very slowly. I really wanted to know why a fisherman would love just one particular fish with so many choices in the sea.

He slowly pulled his pole back, the tip gently bouncing along, and then he reeled slowly. As he spoke, I baited up and got my line back out, not as far this time but far enough.

"Halibut is born and looks just like any other little fish—an eye on each side. But as he gets older, one

eye just moves over, right next to the other, on one side of his face, and soon as that happens, he's lying on the bottom and becomes a flatty."

That made me giggle. "A flatty!"

Just then Bill froze. "Here we go, got one going now." Ever so slowly Bill opened the bale on his reel and the line started to pull out a little at a time.

"Come on. Just gonna let him run." Bill didn't jump up and yell "hook up," he just kept smoking. In fact, he didn't even sit up; he just let the fish take the bait, and then he looked at me and winked. "Let's see what we got," and he set the hook.

With a quick pull back, his pole bent over and the fish was on. "Best bring your line in now. Don't want to get all tangled."

I was stunned. My heart was racing. Bill had a fish on, and he was so quiet and calm. I was reeling as fast as I could, and soon my bobber was on the wharf.

The fish would pull out line, and then Bill would reel in, and then the fish would run. I was so excited. Looking down into the water, the anticipation of the fish on Bill's line coming to the surface was all I could imagine.

"It's a small one," he said. *How could Bill know how big it was?*

I watched his line cutting the water. Monofilament was hard to see, but where it cut the surface it left a small wake. I could see a form now. The water magnified the fish. As it approached the surface, the

color and shape made it clear. A halibut. It was brown with dark splotches on its back. The fish circled effortlessly and Bill brought it slowly to the surface. The fish's mouth opened, and I could see the red gills as it tried to spit out the hook.

"It's just a baby. Let's see if we can land it without hurting him. Grab that net over there for me."

Bill put his smoke out. Behind his tackle box was a coil of rope attached to a circled net stretched over a metal ring about three feet in diameter. I saw crab fishermen use the same thing. I handed Bill the net and line. He sat forward in his chair, and with one hand on the rod, the other lowered the net and scooped up the little flatty just like that!

"Grab the line and hoist it up."

I started hoisting the fish, and as it came closer I could see its eyes and teeth. As I lay the net and fish on the pier, it started to flop and make a smacking sound. Bill took his rag and lay it on the fish, and with his pliers in the other hand, he removed the hook. The fight was out of the little halibut and his gills were gasping for breath.

"Need to be at least 22 inches for a keeper. The reason I only catch halibut is not only are they one of the great fighting game fish but mostly because you get four filets." He pointed to the back. "One … two," and gently flipping the flatty over, "three … and four."

"Can I touch it?"

"Sure. Just be careful of those teeth. They'll take a

bite out of you."

The cool, soft feel, the tiny scales. A film of slime covered its back. And then the mouth snapped and I jumped back.

"Let's get this little fella back in the water." Bill carefully held the fish over the side, speaking to it. "Now you go tell your daddy that Bill is here," and he dropped the fish into the sea.

The halibut hit the water and just lay there, and then with one undulation of its tail, flew into the depths and back to the bottom. Bill wiped his hands with the rag and coiled the rope to the net, then put his pole into the holder.

"Any luck?" It was Jose back from the cleaning rack, holding his fish. "Hey, I heard that there's a giant bass in the cooler at the tackle shop. Want to see it?"

I was in such a hurry to get my line in the water after seeing that halibut, I just shook my head no. "I think I'll stay here. Maybe later". All I could think about was what was in the water right in front of me—bonito and halibut. I was determined to hook up. I was glued to this spot and wasn't moving, even to see a giant bass in a big cooler behind glass. I went to cutting bait off my sardine.

Jose held up his fish, "I'm going to take my fish home and put it in the cooler. Have some lunch. Maybe see you later?"

"My mom is picking me up at 5, so I'll be here all day," I said without looking up.

Jose tied his pole to his bike, hung his bonito under the seat, and with an "Adios, hasta luego," he was on his bike and sailing down the pier, a big smile on his face, and comments like "Nice fish" and "Where did you catch it?" coming from some of the kids as he passed them by.

"Well, I seem to be out of anchovies," said Bill. "Watch my gear, will you? I'm going to have to break down and buy a bag of bait."

"Sure."

Bill slowly got up out of his chair and stretched, making an "ahh" sound as he put his hands on his hips, adjusted his hat and set off down to the finger where the bait and tackle shop was located.

I took a small piece of sardine and hooked it securely on my hook and, as taught, carefully let it hang out over the edge of the pier. Slowly and carefully, I swung it back under the pier, then out over the water, then back and forth until I had enough inertia. Then pushing the button, I let it fly. Out it sailed, and then the weight and bait plopped into the sea and the bobber settled over the bait.

I could see the small fish from under the pier race out from the shadows and congregate near my bait. The bobber dunked and I pulled back; the bobber jumped out of the water and the small fish scattered then quickly returned to the bait. But before they had a chance to steal my bait, they scattered and disappeared under the pier.

From up the pier, fishermen were looking over the side, and like a crowd in a stadium making a wave shouted comments like "Here they come!" and "Get ready!" and behind those voices, "Got one!" and "Hook up!" The comments and excitement were getting closer to where I was sitting. I could see poles bent over and fish, sometimes two or even three on one line, being hauled up out of the water and onto the pier.

I looked out into the water where many fishermen were pointing. A dark shadow was approaching. The water above the shadow was boiling; seagulls and a few pelicans hovered above. Now I could see the school. It was hundreds of mackerel shaped in a wedge and moving fast along the edge of the pilings. Their perfect shape allowed them to move effortlessly through the water. Green and blue stripes on their backs, thousands of stripes, and the shine of the silver on their bellies. Black tails all in unison. The shape of the school was awesome, and I just stared as they quickly passed in front of me.

Suddenly my bobber was moving with the school; then, as suddenly, my bobber joined the school, disappearing into the mass of stripes and fins. I felt the pull on my line. My heart was in my mouth again. I didn't have time to set the hook. The fish was on, and his struggle on the end of my line was in my hands. The violent jerks bent my pole over, and as the school left the area in front of me, I could see the fish as the

bobber surfaced and made a wake as the mackerel went up and out and zigged and zagged in front of me. All I could hear was my heart, and it was all I could do to hang on. I forgot to reel, I was so hypnotized by the fish. Both hands just froze to the handle of my pole. The fish dove and the bobber disappeared, only to surface out in front of me. I had a fish on.

"Hook up, hook up, hook up," I just muttered to myself. Inside my head I was screaming, but my voice was gone and the excitement of the moment took my breath away. The fish was alone now and a few smaller fish ventured out from the shadows, picking up the scraps of sardine that came from the mackerel's mouth. The fight was out of the fish, and it slowly moved in small circles below the bobber. I was alone with no one to share my excitement.

I started the long-haul reeling in. Leaving the still ocean surface, first the bobber then the weight and then the fish slowly rose from the surface. The fish began a violent wiggle and the end of my pole danced with every move. This was dead weight, and I cranked as hard as I could. Finally the bobber came into view

and my reeling came to a stop when it met the eye on the end of my pole. I held my rod high, and there was my catch. The brilliant blue and green, the flash of its silver-white belly against the horizon of sea and sky was locked into my memory forever.

I lay the fish on the deck and immediately pounced on it. It slipped from my hands several times before I got a secure grasp. I could barely get both my hands around its belly. This was a pacific mackerel and a fat one at that.

"Well, look at what the dog drug in." It was Bill back with his bag of frozen, salted anchovies. "Now that you got him, what are you gonna do with him?"

"I'm gonna eat him! I said. "I'm gonna put him on the barbecue and have him for supper!"

"Here. Wipe some of that slime off before you get it all over the place," he said, tossing me a rag. I held the fish to my breast with one hand and picked up the rag with the other.

"No, no, no. Now you got slime all over your shirt. I think the fight is out of that fish. Just lay it down and clean up."

Bill was right—the fish stopped moving, and I was pretty slimy. I laid the fish on the wood, and wiped up as well as I could.

"Best gut that smelly ole fish soon before it goes bad."

After removing the hook, I put my index finger through its gills and out its mouth, and opened my

tackle box to find my knife. I grabbed it and stuffed it in my back pocket.

Bill said as he sat down in his chair, "Make sure you clean out all the blood along the back bone."

"Yep, I sure will," I said, and ran off to the fish cleaning sink.

Racing through the cars, tourists and fishermen, I held up the fish in front of me just to look at it. I was still so excited about what I had done all on my own. I got to the table and there was a man with a bucket full of mackerel. He was a Filipino man. He had a radio with him and was singing along to "KIST 1340." I sat down and waited my turn, holding my fish tightly in my little fist. I played over and over in my mind my catch.

The fish cleaning facility was next to the gate that led to the end of the wharf. The fish processing plant was a large building that took up the entire end of the wharf. Commercial fishermen would unload their catches, and the fish would be cleaned, filleted or processed whole. A boat was unloading boxes of red and orange snapper. The man at the sink had a whole bucket of fish to clean and was in no hurry, and his singing was sort of off key. "Volare, oh, oh, Cantare, oh oh oh oh."

He even imitated the disc jockey when he did ads for the local department store. "You can get every-thing you need at Ott's." This fellow seemed a little

strange to me, so I gave him some space and walked over to the fence.

The fish were boxed on the boat then hoisted from the boat to the pier deck. Two men with rubber boots picked up the boxes and carried them into the building. A truck pulled up to the gate and honked its horn. The gate was opened by an old man who sat fishing, except to open the gate. He then ran back to his pole and was busy with a fish on his line and didn't notice as I walked in when the truck entered. The driver got out of the truck and went into the office.

I stopped to look at the giant red fish in the box. Their eyes were black and bulged out of their heads. The bladders were sticking out of their mouths, caused from the extreme depths from where they came. These fish were so big, my mackerel would have easily fit in the mouths of these deep-sea creatures.

Another boat was pulling in to the next hoist, so I wandered up the pier and looked over the side to see what was in its hold. Standing out of the way, I could see into the back of this boat—net bags of large red abalone were stacked neatly in rows. These giant shelled snails were a highly prized commodity. They were removed from the ocean depths by deep-sea divers with abalone irons. These divers used hookahs and compressed air to gather this amazingly delicious shellfish.

Once they were brought into the building, they

were scooped or shucked out of their shells and then sliced into steaks; the steaks were then tenderized by beating them with wooden mallets. The sound of the pounding was so loud you could hear it from just about anywhere near the end of the wharf.

I wandered over to a window. In the long building I saw maybe a dozen oriental women in aprons with rubber gloves and rubber boots, pounding the abalones. Several men shucked and slid the guts down the table, and then another man carefully sliced the abalone foot into perfect, thin steaks. The sound of shucking and pounding was musical to me. And all the while, water was washing away everything that wasn't used, down the trough and into a hole and into the sea.

A waterfall of fish parts cascaded under the pier, and I was drawn to a small hole in the deck where I could see under the pier. The waterfall and the shafts of light gave view to a montage of colors and movement. A small kelp forest grew there. Large spider crabs clung to the pilings that were fat with mussels and scallops. Fish of all shapes and colors moved together in the feeding frenzy.

Calico bass with their white and brown spots darted through the anchovies, smelt and mackerel. Large rubberlip perch and buttermouth perch seemed to float up and down the pilings. A bright orange perch swam into the center of the light, and I could see it raise the dorsal fin on its back. The fish

was small but fearless—this was a garibaldi. When it ate its fill, it swam into the shadows. A school of opali dominated the feeding zone. All you could see was the large white dot on either side of their backs.

This world captured my imagination, and on my hands and knees with my mackerel tightly held in one hand, my face glued to the hole in the wood plank, I didn't hear or feel the vibration of the large truck backing up towards me. The huge flat-bed stopped just feet from where I was kneeling. I wasn't aware of it because I was completely absorbed in the world under the wharf. All I remember was being lifted up off the wood and suspended in the air. I slowly turned and looked up into the face of the same truck driver who I had run into earlier in the day.

"Didn't I tell you to keep away from the hoists, you little wharf rat!" Being so far off the ground was shocking enough, but this man was big and mean-looking and I was too scared to say anything. But I wasn't that scared because I didn't drop my fish.

"Hey, Tony, how did this little wharf rat get by you … what are you doing!" Tony was busy landing a mackerel.

"Hey, we got fish here. Throw him out yourself!"

The big man put me down and shook his head. "Get outta here and don't let me have to do this again!" He gently let me go and, just like that little halibut Bill set free, once I got my bearings I was out of there, fish in hand.

I ran out the gate and made a beeline to my pole. When I arrived, Bill was sitting in his chair asleep. I stood there gasping for breath and realized that my fish still needed to be cleaned. I made an about face and raced back to the fish sink. The sink was empty now, so I set to cleaning my fish. I had to climb up on a crossbrace that held up the sink so I could reach the faucet. My knife, about a 4-inch blade, was in a leather sheath. I removed it and set to cutting the belly open. I had only cleaned little perch up to now so I wasn't that good at making a clean incision, and my knife wasn't that sharp, but I knew by watching other fishermen. Poke the end of the knife into the small hole under the belly and slice up to the two fins under the head.

I was cutting the best I could, more of a zigzag than a straight cut, when a big gull landed on the end of the table. I think the gulls on the pier knew me, and that with persistence felt they could take advantage of me. As I stripped out the entrails, the big gull stepped closer. I looked at the gull; the gull looked at me.

"You're not getting my fish." I went to cleaning. There was a little bit of cutting to remove the gills, but I did it without removing the head. Now, there is no flesh on a mackerel's head to speak of, but I wanted it so I could carry it like Jose did with his bonito. Fishermen called it a stringer. I had a small cord in my box, and I would hang my catch on it so everyone could see.

I took the entrails and gills and held them out to the gull who stepped close enough to stretch out his neck and, very wary of my every move, snatched the guts and was in the air. I took my blade and scraped out the dark blood along the inside of the back bone, and rinsed off my catch. I was feeling pretty thirsty about now, and the water from the faucet was fresh-water, so I pulled myself up and drank my fill. Then I climbed down and returned to my spot on the pier.

Bill was still in a snooze, so I was quiet while I put my fish on my stringer and, not wanting a gull to snatch my catch, I laid it in my tackle box. Then I baited up my rig and plopped it into the sea.

It was about noon and the sun was warm now, so I took off my sweatshirt. The fog had cleared from the foothills. I could hear the local freight train as it sounded its horn on its pass through town. The hum of Highway 101 was a dull drone. No clouds and bare-ly a breeze. The glassy sea was crystal clear, and the bottom was almost visible. The shadows and light in the water were mesmerizing, so I didn't notice when my bobber went under the surface.

I had put my pole down beside me and was lost in the deep when my pole jumped. I quickly grabbed it.

"Jeepers!" I exclaimed. This woke Bill from his nap.

"Got another one, have you?" He stirred and be-gan to roll a smoke.

This fish fought, but not as hard as the big mack-

erel. I could see it on the hook. Several others swam at its side. I hoisted the fish up onto the deck.

"That's a Spanish mackerel," said Bill. "That's the perfect bait for a big 'barn door.'"

"What's a 'barn door,' Bill?"

Bill went to get his pole ready as I removed the hook. The little Spanish mackerel was thinner and greener than the big Pacific mackerel. Other than the color and the size though, it was pretty much an identical fish.

Bill took his hook and placed it through the back just behind the dorsal fin on about two feet of steel leader, then a swivel and then a sliding sinker.

"Now I'm going to tell you a secret. I fish in this particular spot because all the sport boats come in here. When they do, the props stir up the bottom and create a nice sandy hole. Those big halibut like that." Then he stood and cast the live bait right where the big boats docked. "Listen, mind my pole while I step over to Moby Dick's and grab a coffee and use the restroom. Do you mind?"

"Oh sure, Bill. I don't mind."

"Now, I'll set the drag and the clicker here so if anything hits, you'll hear it." He carefully placed his rod in the holder and slowly made his way across the pier and into the restaurant. Bill's pole was about eight feet long and the eyes were wrapped with beautiful colored threads and then lacquered. The reel was a black spinning reel, and I could smell the oil and grease.

The end of his pole would move every once in a while, and I almost grabbed it to set the hook when I remembered he had on a live bait. Now, that little mackerel gave a pretty good fight on my pole, but on Bill's, held to the bottom with a big lead, all it could do was swim in circles just off the bottom. And that's just what a big halibut would want.

I baited up my rig and cast my bobber out. The bite was off—no fish could be seen. The sun was directly overhead now, and in the far distance I could see the half-day boat approaching. A cloud of seagulls hovered over the stern, occasionally diving into the wash left in the boat's wake and fighting over fish parts. The bait boys were paid extra to filet the fishermens' catch, so when they disembarked, all they carried was a small bag of skinned fish filets.

I was feeling hungry, so I opened my tackle box and took out my peanut butter and jelly sandwich. There it was, directly under my fish. I didn't wrap the sandwich in wax paper, I was in such a hurry that morning, and of course I didn't anticipate my mackerel, so the sandwich was sort of squished and smelled a little like my mackerel. But it tasted good. I sat back in the shade of a post and enjoyed the view and the lunch.

As I gazed upon the coastal mountains, daydreaming, my eyes started to droop when I heard a tick … tick …. I stopped chewing and turned my head to the sound. Tick … tick … tickticktickkkkkk …. With the

sandwich in hand, I jumped to my feet, removing Bill's fishing pole from the holder. The fish was on a run, and my sandwich fell to my feet. The pole was a lot heavier than mine, but the balance was perfect. The tick-tick was now a zzzzzzzzzzz. As I pulled back, the drag was loose, so I set to try and adjust it. That's when a gull quickly took advantage of my situation and snatched my sandwich. I tried to reach for the sandwich, simultaneously attempting to adjust the drag, and that's when I lost my grip and the pole fell into the ocean. Down into the sea. I screamed and a couple of tourists stopped taking pictures and asked what was wrong, if I was all right, if someone fell in. I just stood there in shock and started to cry.

The half day boat was almost at the end of the pier. I turned toward Moby Dick's restaurant to see Bill exit the door with a cup of joe to go in his hand. I didn't know what to do. What could I do? I had just dropped Bill's pole into the sea, and now it was on the bottom. I started to shake from fear and embarrassment. I felt like jumping into the sea.

"Where's my pole?" I heard from over my shoulder.

I just stared down into the water. I could see my reflection. I could see Bill's reflection as he looked over my shoulder. The big engines from the sport fishing boat were in reverse and the props sent a surge that clouded the water and made the glassy reflection a churning, foaming torrent. Bow and stern lines were tossed up onto the pier, and deck hands tied them to

the big cleats.

But I don't remember hearing a thing, only silence in my head. I pictured in my mind Bill's pole silently bouncing across the bottom, being dragged along by some phantom fish. Was it a halibut? A big sand shark? Or a bat ray? I had no idea. I could only stare into the water below, terrified to look into Bill's eyes.

"Where's my pole, son!" Sounds came back to me, the engines of the boat, the excitement of the crowd, the call of the gulls and the lapping of the chop against the pilings. This was the first and only time I remember Bill raising his voice above a loud whisper.

I pointed my hand down into the foam and with convulsive sobs said, "I dropped it in the drink. You had a fish on, and I got all fouled up trying to make the drag work, and it just fell into the sea."

Bill was quiet and sipped his coffee. "I see." He sat in his chair and smiled. "Now, just calm down. Everything is going to be just fine. Let me just think here … you say there was a fish on the line?"

I stood there and explained as best I could what had happened, and Bill listened ever so patiently.

"Well, nothing we can do about it until the boat leaves, and that will be awhile cause they got to take another load out for the evening bite. Why don't you run over and see what they caught. I'll watch your gear."

Bill sat in his chair and rolled a smoke. I could tell he was upset and needed to think, so I just sort

of backed away from him and wandered over to the gangplank. I was surrounded with sounds, sights and smells of fish and fishermen. As the fishermen walked up the ramp to the pier deck, kids crowded around the gate.

"Any fish you don't want, mister?"

"Can I see what you caught, mister?" I heard a kid ask one fisherman with an exceptionally full gunny sack. He stopped and lowered the big sack off his shoulder and opened it so the kids could have a look. They gathered round and peered into the open bag. I had to see too, so I wedged my way into the crowd. Bonito, barracuda and calico bass filled the bag. They were all large fish.

"Wow!" and "Look at that one!"

The heads and fins were piled all together in a tangled ball. Kids were excited, and the fisherman was sunburned and tired.

"Seen enough?"

"Any fish you don't want, mister?" one kid asked.

"Not this time," and he closed his bag, gave the end a twist and heaved it over his shoulder.

The kids were on to the next fisherman with a bag off the gangplank.

The sight of those big fish didn't ignite my imagination as it had in the past. The sounds around me seemed to fade, and I found myself wandering through the crowd. What had I done? What could I do? What would I tell my mom? Would I have to pay

for Bill's pole? How could I even afford such a pole?

I started to run. All I could think of was Bill's pole falling into the water in front of me, the splash, and then it slowly disappearing into the sea. I could feel my lower lip curl and tears flow down my cheeks. I wanted to go home. I wanted to climb in my bed and go to sleep, to sleep and dream, to just get away.

Running through the crowd, I looked across the pier, and there was Bill in his chair, head down, alone except for a few gulls and pigeons on the rails around him. All the excitement was near or on the half-day boat. New, hopeful fishermen were now boarding.

"We had a great morning, folks, and everyone made their limits. Jackpot was won by Buddy Bottoms with an 18-pound halibut. Congratulations, Buddy. Good luck!"

The word "halibut" was ping-ponging in my head and made me run faster. All the commercial boats had finished their business and the boats were all gone, so were the trucks, and the fish conveyor was shut down and quiet. The bite was off and fishermen were leaving for lunch. The sight of Bill, alone, sitting there, with his head down was more than I could stand. I ran. The sounds of the excitement at the landing faded, gulls and pigeons flew up in my path. I could only hear my heart and my breath. I stopped where the finger of the pier led to the tackle shop. I had to catch my breath. I leaned over, putting my hands on my knees, swallowing hard. My heart

felt like it was going to burst. I was standing in front of The Shell Ship.

The woman gave me a "shoo" and waved her fat little hand at me. She was always chasing us "wharf rats" out. It was a place for tourists, not local kids. Then I remembered Jose told me about the giant bass in the cooler of the tackle shop, so I ran over to look. Through the open door, a man behind the counter was having a conversation with a customer. They were laughing and smoking. Rows of beautiful poles were racked in the center of the store. On the walls were stuffed game fish—marlin and sailfish, yellowtail and albacore, even steelhead.

Under each fish was a brass plaque with the name of the fisherman, the date and location caught, and the species. Under the steelhead, it said Jimmy McCaffrey, Mission Creek, 18 pounds, 1951. From where I was standing, I could look out the window and see the mouth of Mission Creek. Right there. Just inside the shoreline, right in front of me, this beautiful fish was caught. Under the yellowtail, it said Dale Howell, Naples Reef, 62 pounds, 1950. The largest calico bass I had ever seen was on the wall: Gene Camby, Camby's Reef, 18 pounds, 1954. The fish looked like it had a basketball in its tummy, it was so fat. That was a bass. *How much bigger could a bass get?* I thought. On the other side of the shop, another fish caught my eye.

This fish looked like a fish that halibut fishermen caught all the time. This fish annoyed the halibut fish-

ermen, and they often referred to it as a "trash fish." I walked across the room to have a better look. Sure enough, it was a giant "ronkey door." That's what the locals called them. The plaque read, "White sea bass, Mike Moropolus, Carpenteria Reef, 57 pounds, 1953. I had been in this shop several times but had never taken the time to read the plaques or the names.

All the big fish were mounted in dramatic positions, most with their mouths open, tails full, and all fins out in a fighting appearance. But the biggest of all was a swordfish. The head was over the front door and the tail was out the back wall. This left to the imagination the size of its body.

Photos taken over the years hung from the walls, of fishermen with their catches laid out on the decks of boats or held in their hands. The whole history of local sportfishing was on the walls.

"Need something, son?" The man from the counter was leaning to one side of the customer he was talking with. I just stared back, expecting to be told to buy something or leave.

"I just came in to see the giant bass."

"Well, it's up here in the cooler. Have a look."

I made my way to the big cooler, which was usually full of frozen bags of bait—anchovies, sardines, squid and mussels. Stepping up on the footstool that was placed there just for kids like me so they could reach the bait bags, I gazed upon the biggest fish I had ever seen. Through the glass, lying on the bags of

bait, was a very large black bass. The head was the size of a watermelon. The large black eyes were glazed and frozen. The fish just fit in the cooler, and the cooler was about six feet long.

"What kind of bass is that, mister?"

"That, young man, is a baby Jew fish. One hundred and forty-five pounds." The man behind the counter was waiting for the next question.

"That's a baby?"

"That's right. Have a look at the photo down there by the leads."

I had to see the photo because if this fish was a baby, I could not imagine what a mature, full-grown Jew fish looked like.

I walked down the aisle of fishing poles, all sizes and colors, shiny and new.

Immediately, Bill's pole came to mind. I just could not get the image out of my mind, of his pole falling from my hands. I saw the boxes of leads, and there on the wall was a photo of a giant black sea bass. A man with his rod was standing next to this behemoth. It was hanging from a hoist on a pier. The man was dwarfed by this giant. Under the photo it said, "Black sea bass, Jack Morehart, Anacapa Island, 485 pounds, 1948. I had no idea a fish like this existed, but there it was.

I wandered again up to the cooler and stepped back up on the foot stool to view this big fish. The man behind the counter had in his hand one of the

many reels kept in the counter under glass and was getting ready to load it up with line.

"Why do you call it a Jew fish, mister?"

The shopkeeper kept to his work, putting on some spectacles hanging around his neck and reaching for a roll of monofilament line. "Because they can live to be as old as Moses."

Well that didn't make a bit of sense to me. *Who was Moses, and what was a Jew?* I thought to myself. I didn't have the slightest idea, and it wasn't that important. Anyway, Bill called halibut "flattys". Bonito were "boneheads," and barracuda were "berries." And from what I saw on the wall, baby white sea bass were "ronkey doors." Even though I didn't yet know that a "ronkey" was really a species of croaker, the point was there were names for fish that had no real meaning other than a name. It was all too confusing for me, so I just shook my head and let the thought go.

As he tightened the new reel to the counter and started the motor spinning and filling the spool with line, I asked, "Who caught it?"

The reel spun and the big spool of mono spun, and without looking up he said, "Give me a second, and I'll tell you soon as I'm done here." That machine didn't take long and the reel was full in no time.

I patiently waited. After all, most of the time, folks on the pier were chasing me out of their shops or away from the hoists. So the fact that this man was

willing to talk to me about fish, and about one really big fish that I was looking at, made me feel like what I expected a customer must feel like.

"Penn Senator, 400 yards of 35-pound test." He placed the reel in a bag, shook the customer's hand, and the man paid and left. Now it was just me, the shopkeeper, and the giant black "Jewish" sea bass.

He stepped over to the cooler, lowered his glasses, looked me in the eye and said, "I caught that sucker, sonny. Right over there on the end of the finger, two nights ago. Have a look at this." He pointed to an article cut from the local paper.

There he was with the fish. I read the caption, and I read out loud, sounding out my syllables because I wanted the shopkeeper to know that I knew how to read.

"Giant black sea bass, Stearns Wharf, caught by Richard "Dick" Shea."

"That's me. You can call me Dick, sonny."

"What did you use for bait, Dick?" I asked.

"Squid," was all he said.

"How did you land him?"

"On the ramp that goes under the wharf. Used that big old gaff over there." He motioned with his hand. Against the wall were some of the biggest hooks I'd ever seen. Some were on poles and some on lines. "Took three of us to haul him in. Are you a fisherman?" he asked.

"Yep."

"Well, just remember this—the biggest fish are always under the pier." Reaching over and tapping on the glass cooler, he continued, "If this big ole blackie don't prove that, then I'm a monkey's uncle." That made me laugh and Dick laughed too. Suddenly, I felt serious.

"What's the matter, son?"

Bill, I thought to myself. The half-day boat must have left by now. I had to get back. I had to apologize. I had to do something. Besides, Bill must have thought of something by now. Older fishermen were pretty smart.

"I got to go."

I found myself in a dead run back to the landing area. The half-day boat was just clearing the end of the wharf, under full throttle towards the open ocean. I could see Bill on his feet with my pole in his hand. *That's it!* I thought. *I can give him my pole.* It was the least I could do.

I ran up behind Bill and even though I was winded, I blurted out, "You can have my pole, Bill. I want you to have my pole, please!"

"Hang on now, son."

Bill was concentrating on slowly reeling my little reel. He was very intent on what he was doing. I thought it was best not to say a word, just to watch. He shook his head, made a slight noise with his lips and reeled up the line. On the end of my line he had a treble hook tied and a big split shot.

"Show me where the pole fell," he said in a very calm whisper.

I looked over the edge into the sea and, trying to catch my breath, I said in as calm a whispered voice as Bill's, "It was right over there," pointing my index finger. But my voice squeaked and it didn't come out as calm and cool as I hoped it would.

Bill sized up the location and then said, "Which way was the fish running?"

Again, there was no urgency in his voice, but my little heart began to pound, and with my eyes closed, I tried to remember. I remembered reaching for the pole. The spinning of the reel. The line racing out and away from the pier.

"There!" I said, pointing toward a sailboat. "The white one anchored right there!"

"Ok," he said, and moved down the pier about twenty feet. There was no one around. It was early afternoon, and it seemed like there was only Bill and me.

"Grab me a couple of those big split shots from the top drawer of my box." The big box was open, and I pulled out the top drawer.

"Big split shot, big split shot," I muttered. There they were, about the size of big green peas. I palmed several, closed up the drawer, and hurried over to Bill, holding them out to him.

He looked at me and said, "That'll do." He put the shots on the line, but this time he closed them with

his teeth instead of pliers.

The sea was dead flat and it was easy to see the small patches of kelp and dark shadows on the bottom.

"That little white boat, ya say?"

"Yes, sir."

With that, he looked to the empty pole holder pointing with my rod, then to the sailboat, doing the same thing, kind of like a teacher with a pointer in front of a blackboard. Then without warning, he whipped an overhead cast. Hook and leads sailed out and splashed about 100 feet from the pier.

I was amazed at the distance of the cast. I never thought my pole could cast that far, but it did. The big hook sank, and the line went slack when it hit the bottom. Very slowly, Bill reeled in, using the pole, bouncing the hook along the ocean floor.

"If I'm right and you didn't tighten the drag, that big fish ran out a safe distance from the pier and forgot about the hook and is resting, digesting that little mackerel of yours, just out there." He pointed with my pole and continued to reel slowly and work it back and forth and up and down.

"I had about 350 yards of line on that spool. Now it's only a 20-pound test, and this here is only a 12-pound, so I've got to be very careful not to pull too hard. Don't want to wake that fish up, whatever it is. I just want my pole back."

"I want your pole back too, Bill."

Bill kept a constant pull on the hook. Slowly, slowly, he reeled and pulled. "Don't want to get snagged either," he said.

Then my little pole started to bend. Bill stopped reeling.

"Think we got something here."

The excitement was building, I could feel my little heart pick up its pace.

"Yep, we got something here," he said as he gently continued to bring in the line.

The line from the pole started to surface, cutting the water in the direction of the sailboat. More and more line appeared, leaving a trace on the surface of the placid flat sea.

I could see the shining silver hook now. It was flashing about ten feet below the surface and several small fish raced toward it, only to bolt at close inspection. Unseen weight from the bent pole meant only one thing—Bill had snagged his line. The hook came to the surface, and I could see the line it held.

"I see it, Bill! I see it!"

Very slowly he pulled it closer but the line was green, not the mono that had been on the pole. My heart sank. He must have snagged some other lost line.

"Yep, that's mine," he said.

I was confused, I was sure the line Bill had on was mono, not cloth.

"That's my backing. That fish pulled out a lot of

line. Yep, a lot of line." Now the hook began to slide along the line towards the pier. "Have to keep it taut or we'll lose it."

By including me, Bill made me feel like I was part of this whole event that was taking place. My bait on Bill's hook caught the mystery fish. My pole was being used to retrieve Bill's pole that I dropped. We were both pretty happy fishermen at that moment, attempting to fish his pole from the bottom of the ocean.

As he kept up the tension on the line, he slowly made his way back up the pier to where his chair sat. When my little pole bent, Bill stopped reeling, and the pole bent even more as he slowly raised it. He tightened my drag and continued to reel and raise the pole.

He did his until he said, "There it is."

Looking down and out into the clear water, I saw the tip of the pole beginning to come into view. Very slowly he cranked until the tip broke the surface. My little pole was bent so far that I thought for sure it would break at any minute. I found myself holding my breath.

Not a breeze, not a whisper of a sound. Just the tick, tick, tick of my reel, and Bill's pole just 20 feet below us.

"Take your pole, son. I'll hand line it from here."

He handed me my pole, and with both hands on it, I grimaced under the weight and fear of it snapping. All I could think of was the snap of the line.

Bill got on his hands and knees and began to slowly wrap the line around one hand, then the next, slow and steady. The weight was off my pole and it slowly straightened. With every handful of line, Bill's pole was surfacing eye by eye, then finally the reel and then the handle, and then only the drip of water splashing back into the sea. I held my breath. Higher and higher it rose until the tip was within reach.

"Got it."

I exhaled and so did Bill. I almost fell down from the dizzy feeling of holding my breath. Once the pole was in his hand, he quickly unhooked the treble hook.

"That fish took every bit of line." A closer look showed the knot that held the backing to the spool. He inspected his reel for any damage and gave it a shake. Giving the reel a few cranks, he looked down and gave me a small smile and a wink.

"Just like new," he said.

"Just like new," I repeated.

"Well, whatever it was, it pulled every bit of line and drug the pole about 20 yards. Yep, whatever it was has some size. Well … shall we see if it's still on?"

"Oh yeah, reel her in, Bill!"

And slowly Bill began to reel in his line. The backing was a green linen line about 30-pound test, but the mono was less. There was slack in the line, and Bill wanted to get as much backing on as possible in case the big fish woke up and made a run for deep water. The more line on the spool the better. He

would have something to fight with.

What was on the line? I wondered. There were several possibilities.

"I don't know if you noticed, but I got a steel leader on and that should hold whatever we got, if he's still hooked up." As Bill cranked in slowly, my mind raced with the possibilities.

After seeing the giant black sea bass in the cooler, I knew that there were giant fish out there.

"What's a 'barn door,' Bill? I asked again.

Bill kept a steady turn of the handle, and his Mitchell reel purred. The backing was almost all on, and the knot that connected the mono to the linen was just coming into view.

Bill started to speak, "Didn't I tell you? Guess not. A 'barn door' is a really big halibut. Up in Alaska, they get to be the size of a 'barn door,' so they give 'em the name. Down here off the wharf, anything over 20 pounds we call a 'barn door.'" Bill's line went tight and his pole started to bend. Bill stopped; I held my breath. His focus went to the tip of his pole. He had about 50 yards of line on and 300 yards to go. The tip moved and the line pulled, and then went slack.

"We got something. Sure could use a little more line though."

He tightened his drag just a turn and slowly pulled the pole back. The pole came alive and bent over several times very quickly. The line cut through the flat surface of the ocean, still like a lake. No wind

and no one around. Just Bill and me.

The line was heading up the pier and out the channel mouth to open sea. Bill started walking up the pier, all the while trying to crank in as much line as he could. I was right behind him.

"Got to try and turn this fish around," he said as he tightened his drag a little more. With a quick jerk back, he set the hook even deeper into the fish, but that did not seem to affect the fish.

Suddenly, the line went slack. My heart sank. The line didn't snap, but there was no play on the rod. Bill just cranked as fast as he could. I could see his index finger and his thumb pinching the line taut so as not to get a tangle on his spool. He was cranking really fast as the pole came back to life. Still on. The fish was heading straight for the pier. *Could it be a giant black sea bass?*

Now when I looked under the pier, a chill went up my spine as I thought about the creatures lurking in the shadows. In the broken shafts of light, I saw giant eyes and fins. I would never look under the pier the same way ever again. It could be anything and it could be very, very big.

The fish turned and headed back out to sea. The drag sang, and Bill loosened or tightened the drag with skill and precision, depending on the intensity of the pull. His tackle was light, and he knew how to handle it. This old man was alive and young again. He was smiling and moving this way and that. He

changed in a moment from old and still to as athletic as the younger guy who lost the bonito that morning.

Only Bill knew what he was doing. I was watching an artist, but I didn't know it then. This was a big fish, and it was not going to give up for a while, if at all.

"There are some big bat rays and sand sharks down there, and if that's what we got, I'll just cut the line. But we wanna have a look-see, don't we?" He looked to me, and I was so happy to be part of this battle.

"We sure do, Bill," I laughed.

Everything changed for me so quickly, from despair to exhilaration—from the hookup and dropping Bill's pole into the sea, to getting it back again, with a big fish still on, and all of Bill's skill and knowledge coming to a moment in time, a moment like a shooting star. You could sit for hours, staring into the sea, your line still in the water, then bang—a fish is on! You come alive, and the moment of the battle with the fish, the sensation of the pole in your hands, may

only last for seconds, but you will remember it a life-time, especially when the big one gets away.

A few folks noticed Bill and me and wandered over and looked down into the sea.

"What you got on?"

Bill just ignored them and looked at me with a maybe-we'll-tell-you-and-maybe-we-won't kind of smile.

The big fish made another run—a powerful run—and this caught the attention of other fishermen. They left their spots and wandered down to have a look. Soon a little crowd had gathered and everyone had their own idea of what was on the line.

"Just give me a little room, would you mind," Bill asked politely, and the small crowd moved back a bit, still focusing on the line into the water.

The fish was not coming up. It was making big circles about 50 feet off the pier.

Down, down, down the pole would bend with every pull. The drag would buzz, buzz, buzz with every bend.

"He's coming up," Bill whispered to me.

I squinted my eyes, and with the glare of the reflection of the sun on the surface so bright I had to shade my brow with my hand. A large shape was slowly coming into view. Was it kelp on the bottom? Was it a shovelnose sand shark or a bat ray? I couldn't tell.

"I think I see something, Bill, but I'm not sure what it is."

"Just keep watching … if it's a shark or a ray, you can cut my line."

Watching a fish coming to the surface from the depths gives the appearance that it's a lot bigger than it really is, so I wasn't sure if I was exaggerating in my mind when I saw the brown shape of a 'barn door' slowly circle and then, like a light being turned off, disappeared from view.

Bill's pole bent, and the reel sang bzzzzzzz. My eyes were out of my head, just like those rockfish in the box from the end of the pier. *Did I see what I thought I saw?* I looked up at Bill, and his eyes were bugged out too. The fish made another run out to sea, back towards the sailboat. It had been on for 30 minutes and was pulling as hard now as it was when it started.

"Do me a favor."

"Sure, Bill," I said, staring down into the sea, still in awe of what I thought I had just seen."

"Run down to the tackle shop and ask for Dick."

"I know Dick!" I blurted out.

"Listen to me … tell him Bill's got a 'barn door' on and needs the gaff. Would you do that for me, son?" I just nodded my head "yes" and was out of there like a shot.

Gasps from the crowd grew into whispers, turning into loud excited voices. The word spread so fast that as I was running to the finger and the tackle shop, folks were running towards me to see the fish that was on a fisherman's line at the landing.

As I looked over my shoulder back at Bill, he disappeared in a large crowd. Folks were coming out of the diner with napkins around their necks, a car stopped and a fella jumped out blocking traffic, horns started to honk and mayhem broke loose behind me.

I made the corner around The Shell Ship and was running so fast I couldn't stop and missed the tackle shop door. My legs just turned to noodles as I tumbled to the deck. I got back to my feet and raced into the door only to crash into an older man stepping out the door. I found myself on the floor again.

"Hey, slow down. What's the hurry?" he asked.

"I don't want you kids roughhousing in my shop. Take it outside." I recognized Dick's voice, but he didn't recognize me.

I ran into the shop, up the aisle and jumped up on the stool. I was out of breath and pretty excited.

"Hold your horses. I'll be with you in a minute." Dick was busy with a couple of customers; he had several new reels on the counter and was trying to make a sale.

"Dick ... Dick ...!" I could hardly catch my breath.

"Oh, it's you," he said as he recognized me.

"Bill says he needs the gaff." I swallowed. "He's got a 'barn door' on and needs the gaff." There I said it. Now I could catch my breath.

Just like that, Dick grabbed the reels and put them in the case.

"Sorry, folks, I have to close up for a few minutes.

Hope you don't mind." With that he went into the back room and came out with a large coil of rope. On the end was the biggest, sharpest treble hook I had ever seen.

"Everybody out," he said, and then he looked at me. "Let's get moving."

He hung a sign on the door—"Gone fishing"—and locked up. We hurried to the landing and the large crowd gathered around Bill. As we got closer, the crowd began to move up the pier.

"Give him room!"

"Look at the size of that fish!"

When the fish moved, so would Bill, and so would the crowd. "

Coming through!" yelled Dick as he held the coil of line and the big hook over his head.

People parted as we moved through the crowd, I moved in next to Bill. Looking down into the water, there it was. A huge halibut, brown with dark splotches on its back—the giant fish cruising about two feet under the surface. The steel leader was in its mouth and down its throat.

Bill leaned over to Dick, whispering, his attention on the fish. "He's hooked real good, but this 20-pound test will snap just like that if he gets a wrap on a piling."

Dick was a pretty cool cookie too and after a silent stare and a nod agreeing with Bill, he leaned over to his friend and softly said, "That has got to be the biggest halibut I've ever seen caught on this pier.

Might just be some kind of record with 20-pound test. That fish looks well over 40 pounds. You trying to out me?" They both laughed.

I was standing between the two fishermen when I felt that big fish look at me. His teeth were visible as it opened its mouth trying to dislodge the hook.

Bill had been hooked up on this "barn door" halibut for close to an hour, holding the pole over the water as far out as he could, trying to keep the big fish from going under the pier. The fish was tired but kept moving, and wherever he swam, Bill, Dick, me, and the crowd followed up and down the pier. "Get him on top and I'll gaff him," said Dick.

Bill answered, "This big flatty gets on the surface and slaps that big ole tail, he'll snap this line for sure. So as soon as he stops, you're going to have to get a hook in him. Try and get him in the gill plate, or he'll tear off. And watch out for my line. I don't want you to snap it with that gaff."

"Anything else?" Dick said. "Maybe I should call the paper. I'm serious Bill. This might be some kind of record, Bill."

Dick handed me the rope. "Untie this for me, and hold the knot on the end, son."

Dick held the gaff and slowly lowered the hook.

"Maybe you should get the barbecue ready too," said Bill.

I looked up at these two old guys; I was only eight but, "Call the paper"? "Get the barbecue ready"?

"Bill, shouldn't we get that 'barn door' landed first?" I asked.

Bill was concentrating on the pole and the fish; Dick had his eyes on the gaff and fish. Both chuckled, and Bill said without taking his eyes off the fish, "Sounds like the words of a wise fisherman, wouldn't you say, Dick?" Without a glance at either of us, with a small smile, Dick just said, "I'd say he had a good point."

The halibut made a small circle out to sea and then back towards the pier. The big fish was just under the surface. The crowd was quiet except for whispers and heavy breathing.

"Bring him right over the hook, Bill." Dick was leaning over the edge with his arm held out as far as he could.

Bill whispered, "You miss and piss this fish off, you may not get another chance, Dick."

I held the end of the line with both hands. *If Dick hooked that halibut and let go of the line, it would drag me off the pier and out to sea for sure*, I thought.

Just as the big fish approached the gaff, Dick dipped down and Bill pulled gently up. The halibut's head went up.

"Now!" yelled Bill, and Dick gave a quick pull up on the rope. The gaff found its mark. The big hook pierced the gill and the fish went crazy, slapping the surface with its mighty tail and making a frantic attempt to dive. But Dick kept the line taut.

"Got him," Dick grunted.

Voices rose with excitement, and everyone crowded in to have a look.

Dick was holding the line. Bill said, "Keep him out of the pilings, Dick."

But the weight and fight from the big fish was so powerful it was all he could do to hold on to the line cutting into his hands. The massive tail was pounding the sea, splashing foam and blood on the huge white belly of the fish as it was half in and half out of the water.

"I … need … help … here." Dick was doing all he could to prevent the line from slowly slipping through his hands.

All I could do was hold the end of the line. I was frozen to my spot as I watched the battle. The big fish was electric and violently shaking and slapping the water.

"Here, hold this … and don't drop it." Bill winked and handed me the pole.

The two men grunted and groaned as the halibut was slowly hoisted from the sea. I had Bill's pole in my hands again, and I was not going to let it go. The pole and the end of the line ended up in a jumble in my arms. And on the end of each, a monster—a "barn door" of a halibut.

"We'll have to swing him in. On three …," said Bill, " … one …." The big fish, violently shaking the line, swung under the pier and then out into the light where the crowd gasped.

"Oh my god! It's huge!" someone shouted.

Then the big fish went back again under the boards, into the darkness and out of sight, still fighting for its life. When it was under the pier, the crowd would go silent. When it came out from under the pier and into the light, the excitement built to a higher pitch.

I joined in, " … Two …." One more swing, a little further this time." The big fish was still trying to free itself from the big gaffing hook. Blood covered its large white belly.

The crowd joined our voices, all in unison, " … Three!" And with a final pull, the big fish flew up and over my head. Holding the pole and the line, and looking into the blue sky with my mouth wide open, it was as if the giant halibut was in slow motion above me and flying with the gulls. I never in my wildest dreams thought I would see a halibut flying over my head.

I felt the blood and sea spray my face as the fish passed over me and came crashing onto the pier, slapping and pounding the wood planks. Blood was flying everywhere. People gasped, jumping back, and pictures were taken.

Bill gently took his pole from my hands. "You can let go now." I came out of my stupor, releasing my grip. He carefully reeled in the slack and placed his pole into the holder.

Dick coiled the line, and when he got to me, he said, "Good job." I just stared with my mouth agape.

"Better close that trap or the flies will get in," he said and patted the top of my head. As I closed my mouth I could taste the sea and wiped my face with my hand, feeling a slight sting in my eyes from the salty water.

The crowd gathered around Bill, Dick, me, and the giant halibut. The violent slapping of its huge tail was slowing to a quiver.

"I've got to know the weight of this big ole butt. I'm going to get the scale … and call the paper. I'll bet it's some kind of record, Bill." Dick hurried off through the dispersing crowd.

Now the halibut was still. The only movement came from its huge gills, and then it stopped. Soft brown splotches covered its back, and its two eyes were the size of silver dollars. Bill put his foot on the head of the big fish. The huge tail slapped the deck, and I jumped back. Then it was still.

The gill plate was twice the size as the width of Bill's shoe. The whole fish was about four feet long and six inches thick. The fins around the body undulated as Bill removed the gaff. He then reached down with his pliers, opening the huge mouth and exposing large white and very sharp teeth.

"He swallowed it. Have a look at these choppers. They'd take your finger right off," he said, and cut the steel leader. He clipped a large stainless hook through the gill and out the mouth and tied it to a line. Then he coiled Dick's line and gaff. He moved slowly back to his place on the pier, stowed the gaff behind his

chair, and removed his pole from the holder on the rail. Sitting, he then removed his reel from the pole.

I couldn't move. I had just witnessed the catching and landing of a giant halibut.

"See if you can drag that old fish over to my chair while I wash the salt off my reel, you mind?'" he whispered. Bill was exhausted. I was exhausted, and so was the big fish.

Cradling his pole in his arms like a mother holds a baby, he slowly rolled a smoke, striking a match on the sole of his shoe. A slight afternoon breeze stirred the air, so he cupped his hands around the match. He sat staring out to sea smoking, holding his rod and reel, safe from the bottom of the sea, while I held the prize—the giant fish from under the pier. Our introduction an hour before had come to an end.

Wiping off his reel and leaning over to his box, Bill removed a can of oil and a tube of grease. He placed his pole against his chair with reel in hand and slowly got up out of his chair. Putting his hands on his hips, he stretched and uttered a small groan. Bill became an old man again. Every move was slow and deliberate, showing his age as he made his way to the fish cleaning table and the fresh water faucet. The graceful movements, the spring in his step, the intensity of the look in his eye as he snagged his pole off the bottom and fought the giant halibut was over. The dance between man and fish existed only in my memory now.

I slowly turned my gaze to the monster fish on the deck, and picked up the stringer attached to the halibut. I had the fish on the line again, but imagination was no longer necessary. There he was on the deck. The big halibut had swallowed my little Spanish mackerel. I stood daydreaming, replaying in my head, in vivid detail, the events of the past hour.

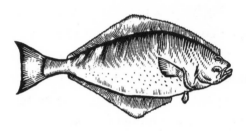

"Holy cow!" Jose had returned and was staring at the big halibut.

I started to pull the fish towards Bill's chair but it was too heavy. Jose immediately parked his bike and lent a hand, and together we slid the "barn door" over to Bill.

"There it is!" Dick was back with a scale and a man with a camera. "I got to know how big this butt weighs," he said as he hooked his scale into the fish's mouth.

"What's it … say?" He was groaning a bit, his two hands holding the big fish, its tail just off the deck.

"Forty-one. No forty-two pounds," said the man with the camera. "That has got to be a record. He

only had 20-pound test too. A California halibut off the wharf … 42 pounds … got to be a record. Where is he?"

Dick looked at me. "Where's Bill?" He looked around. "Don't see him anywhere. Can't be far."

I interrupted. "Bill's gone over to wash off his reel."

Just then, Bill slowly made his way back from the fish cleaning rack. As he arrived the man with the camera pulled out a small pad from his shirt pocket and started asking questions: Who was he? And how did he catch the big fish?

Dick was there with him and told the reporter that it had to be some kind of record what with the size of the fish and the pound test of the line. I gathered my stuff, and Jose and I just stood back as a crowd gathered again.

I think it was the fish on the scale and the flash of the light on the camera that caught the eye of a lot of folks. Bill gave a look my way, that kind of We-did-it! look, and I gave Bill that We-sure-did! kind of look. The last I saw of Bill that afternoon, he was telling the story of how his pole got pulled over the side. He didn't mention me and how I dropped it—that would have embarrassed me to no end. He borrowed another pole and fished it off the bottom and landed the big "barn door."

Jose said, "We still have an hour before the boats come in. Let's change places, try somewheres else."

"I got to pee," I said. I had been holding it for some time, but the excitement of the day kept me from finding time to go.

"Let's stash our stuff, and I'll give you a ride on my bike."

The public restroom was at the foot of the wharf where my mom had dropped me off early that morning. There was no other public restroom on the pier. Restaurants had toilets, but you had to be a paying customer to use them.

"I got a quarter. I'll share my popcorn with you," I said.

So we walked across to the other side and looked for a cubby where our gear would be safe and out of the way. If you left your gear stowed and neat, nobody would bother it. There were a few kids who stole stuff but that was rare. If you asked your neighbor to watch your stuff, usually they would oblige. It was the camaraderie of fishermen back then.

Between the restaurant and the fish processing plant on the end of the wharf was a crab shack where crabs and lobsters were boiled up depending on the season. They also sold smoked fish and shrimp cups. A big old copper pot out in front was boiling, and the aroma of crab and lobster in the air sure made me salivate.

Jose and I stopped to watch as the large top was opened and steam filled the air. The crab man pulled out a wire basket full of bright orange and red crabs

and then dropped in a fresh one. These crabs were boiled alive and this sort of gave me the willies. The drains for the sinks and leftovers, even the cracked and eaten shells, dumped into the ocean out behind the shack. These scraps were enough to draw in any fish that couldn't get a meal at the abalone hole beyond the fence. We thought we could leave our poles and tackle boxes there while we went to use the restroom and buy some popcorn from the popcorn man.

Poking our heads around the corner of the shack, we saw a large black man there fishing, sitting on a small folding stool, a bucket full of perch beside him. As he reeled in his line, we saw two perch dangling on hooks. These were butterlip perch, a beautiful golden-brown perch with orange and yellow lips. He lowered the perch on the deck and this gave me a chance to see his set-up. He had ten or so of these perch in his bucket and was startled when Jose and I poked our heads behind the crab shack.

"This spot is taken," he grumbled, with a quick glance to us and then back to his catch, flopping on the planks before him. He used a rag to grab the perch and pliers to remove the hooks.

These perch had sharp spines in their dorsal fins, and once out of the water those spines were out and up for protection. My experience in eating perch was, first, there were a lot of scales, then the fins had some

sharp points that could really hurt if you got poked, so they needed to be removed. Then the head and tails had to be cut off. And once you fried 'em up, there were a lot of bones—I mean a lot of bones, and not very much meat. And by the time you had 'em all cleaned up and ready for the pan, there wasn't much there, so you had to cook a whole bunch. Problem was I could never catch enough for a meal, so this set-up intrigued me to no end.

"Say, mister, can I see?" I said. The big man looked up at me as he removed the last perch and slipped it in the bucket. Then he went back to getting ready to catch some more. On his line was a large sinker, but the big paper clamp was something I'd never seen. He had a huge pile of mussels in a gunny sack. He jerked one off the bunch, pushed the blade of his knife in a spot near the top of the mussel and split open the shell. Then he took the clamp and attached it to the edge of the shell. Several small hooks were tied on short leaders on the clamp; these he buried into the flesh of the opened mussel.

Jose stood behind me and didn't say a word. I think he was scared of the man, but when the old man smiled at me, I felt at ease. I looked over to Jose and he gave me a nervous little smile.

"We were just looking for a place to stash our stuff for a while," I said.

The big man slowly lowered his line into the ocean below. "Well, I'll watch it for you, young fella. . . but

don't you go showin' nobody my secret set-up now."

He must have seen me studying the contraption, and I didn't even notice.

"Oh no, never."

As he slowly lowered his line back into the sea, voices echoed from under the pier. The dipping of oars and the muffled voices were directly below us.

"We're fishing here!" yelled out the big black man.

"I see your line," a voice echoed.

Jose and I found ourselves on our hands and knees, leaning over the rail to get a look.

"Coming out. . .I see your line."

The bow of a wood skiff emerged, then the hand and shoulder of a man seated in front. Finally into view came two men in uniforms. The officers looked up. One man rowed and one man sitting in the front carried a flashlight.

"Fish and Game," the black man whispered.

"What are we fishing for today, gentlemen?" The officer sitting on the bow looked up.

"Perch officer. . .butterlip perch," he said as he held up one of the golden-brown fish to show the officers.

"No limit, any size," answered the officer.

"What are you officers looking for down there under the pier?"

"Got a tip, there were some divers poaching scallops off the pilings. Seen anything?" The officer doing the rowing held the boat still, but a small wind swell was knocking and scraping the hull against a piling.

The old man shook his head, "No."

"How about you young fellers. . .Seen anyone in the water?"

"You mean under the pier?" I asked.

"That's right" he answered.

Jose and I shook our heads in unison, "No." I couldn't imagine anyone in their right mind going under the pier. And in the water, these men really sounded scary.

"We'll get 'em. Let us know if you see 'em. We know they're here." He pointed to an inner tube with a gunnysack laced to the center. . ."Found their sack. . .we'll get 'em." Then he pointed with his flashlight to another search area.

"Let's have a look-see down the other side."

Quietly dipping the oars, they crept into the darkness and shafts of light. We were all quiet as the rowboat disappeared.

The old man started talking as he readjusted his chair and rod. Almost grumbling as if to himself. "Don't need no fishing license on a pier. And I only take fish with no limit or size." He looked at me and caught my eye. I didn't know what to say, so I just smiled and stared back.

"I don't need no trouble with no Fish and Game. Once you leave the pier, you need a license, and those boys are sneaky fellers," he said, referring to the officers.

Limit and size, I thought to myself. Bill had shared that knowledge with me when he released the small

halibut. He had been very gentle with the little halibut. He had shown it respect by netting it and carefully removing the hook and getting it back into the sea.

"Why isn't there a limit or size for butterlip?" I asked.

"Butterlip is not a game fish, sonny. . .only game fish got a limit or a size."

A game fish? To me, all fish were special and beautiful and worthy of the term game fish. Some fish just got bigger than the others, but anything I could catch on a pier was a worthy catch. Some were just better eating than others, that's all.

"How do you cook 'em?" I asked. I moved closer to his catch to get a better look.

Jose got up and moved to his bike. "Let's go."

The big black man laughed and his belly jiggled as he tipped back his hat. "Fry 'em. . .lotsa flour and butter. . .a little salt and pepper. . .and spit out the bones."

Just like that, his pole began to bounce and he slowly cranked up two more perch. "Just leave your gear. Nobody gonna bother your stuff."

"Let's go," was all Jose said.

"I'll be right back. I just need to use the bathroom."

The old man laughed as he unhooked the fish and said, "Now that's more than I need to know."

"Come on, let's go." Jose untied his pole and tackle box and we placed our gear against the back wall

of the shack, out of sight from the traffic and tourists and close to the black man.

"Run on, now."

We walked out to the center of the pier. "How do I get on"?

"Just climb up and sit here, then hold the bars... but let me steer" Jose held the bike still while I climbed up and sat sideways on the crossbar, and then with a push we were off. Jose peddled and we both held the handlebars. A small afternoon breeze and the speed of the bike cooled us in the heat of the late afternoon. Flags were snapping on the poles, pigeons and gulls flew up in our path and sailed along beside us. We were flying over the water. The rhythm and sound of the bike over the planks and the speed was exhilarating. I had never gone that fast on a bike—past the sardine conveyor, past The Shell Ship and the tackle store. The halibut fishermen were gone, and only one lone fisherman, a woman, had two poles in the water and was sitting in a folding chair doing some knitting.

A little further on, one pole was leaning on the rail with no one around; the line was out in the water and just as we passed, it started to bounce. Something was on it and no one was around. Both Jose and I saw it at the same time. Jose stopped. I jumped off the bike and ran over to the pole, looking for the owner.

"What do we do?" I asked. The pole was violently flopping on the deck now. We looked over the edge, but the fish could not be seen. I grabbed the pole and

adjusted the drag. It was an old pole and the reel was old. The line was cloth and the pole was missing an eye, but it worked. Immediately, the fish took out line, and the memory of Bill's pole falling from my hands made me grip the pole tighter. This pole would not drop into the water.

The woman stopped her knitting and looked at us.

"That's somebody's pole, Tim." Jose had a worried look on his face.

"Well, if we don't hold it, it will flop into the water or the line will snap." There I was with a fish on the line, holding another man's pole again. . .twice in one day.

"I'll ask that lady up there if she knows whose pole this is," he said and raced his bike up the pier.

I had watched Bill most of the day and had learned a lot just by watching, so everything Bill had done, I tried to imitate.

"Use the drag. . . .Keep the tip up. . . .And keep the fish away from the pilings." I said to myself out loud.

The fish bent the pole and the drag sang. When the fish stopped, I reeled in the slack. I could see Jose talking with the lady, and soon he was back at my side, winded.

"She said that the man walked down towards the street. Maybe he's using the bathroom or getting something from the popcorn man. She said he had on a red shirt.

Want me to look for him?"

The fish made a run.

"Holy cow, it's pretty big, whatever it is. It'd snap the line for sure if we just leave it alone," I said.

Jose jumped up on the rail trying to get a glimpse of the fish on the line. "What do you think it is?"

From the fight, it was big. Bigger than the mackerel I had caught that morning, bigger than the little halibut Bill let go.

"It's no bonito," Jose said, his eyes glued to the water. Being this close to shore and with the set-up on the bottom, it had to be a bottom fish.

"A sand shark maybe? Or a stingray? Or a halibut," "I said, whispering like Bill.

The fish moved up the pier, and so did I. When the fish moved down the pier, I followed, Jose at my side.

"See that fella with the red shirt yet. . .anybody with a red shirt?" I said as I kept my attention on the line. Jose kept an eye out. The fish had yet to show itself. But I knew what it was. A halibut. I could tell from the fight. The run, the periodic stop and shake. It was a halibut for sure, and more than likely a keeper. Trouble was, it was someone else's fish. At least it was on someone else's pole.

We were close to shore and a small wind was making one- to two-foot waves on the beach. Not a far walk, perhaps a hundred or so yards from shore. We were only in about ten feet of water, but the small

swell clouded the visibility. The fish made a run, and I started to tighten the drag, reeling in. The shape came to the surface.

"It's a halibut," Jose yelled with excitement.

The fish glided to the surface, trying to dislodge the hook on the edge of its lip by opening its mouth and shaking its head from side to side. As it came to the surface, it smacked its tail, leaving only the splash as it quickly disappeared to the bottom and to the safety of the sand. I was lucky that time. I remember Bill saying that was a sure way to lose a flatty. Once on the surface, a flatty had enough power by slapping its tail to jerk the hook out of its mouth or snap the line.

So we slowly walked the hundred or so yards down the pier, keeping the fish from going under the wharf and getting wrapped up on a piling or cutting the line on the mussels. Soon we were over the small waves. Still, nobody with a red shirt.

I was thinking what I would say, and then politely hand the pole over to the owner. But secretly I was hoping he wouldn't show, at least not until we landed the flatty. The fish sensed the shore and made a run for the open ocean but was tiring. It was about a ten-foot drop to the sand from the pier.

"Jose, hold the pole. I'll jump down, and then you hand it to me." With that I crawled over the edge and hung for a while. I was having second thoughts, swinging in the breeze from the edge of the pier.

What am I doing! I hesitated for a second.

Jose was fighting the fish, and I was hanging off the pier and looking down at the sand. It was further than I thought. *I got myself in a pickle now.* I could smell the creosote, and the hot tar was starting to burn my hands.

" Jump, and I'll pass you the pole. . . Jump! Better jump before the guy comes looking for his pole."

I looked up at Jose, that big smile on his face, the pole bent over the line, tight, as the fish fought the hook just beyond the breakers. I closed my eyes, let go of my grip, and dropped.

"Tim. . .Tim. . .you okay?" I was on my back, the sand warm and soft. The wind knocked out of me, I just lay there before attempting to get up.

"Here, grab the pole!" Jose lowered the pole handle first. There was my friend over me, high up on the pier, in the blue. I closed my eyes and saw the big 'barn door' once again fly over my head.

"Get up and grab the pole!"

As I got myself up on my elbows I was looking into the shadows under the pier.

"Grab the pole!"

The shadows and blackness beyond under the pier sent a chill up my spine. Musty smells engulfed me as a cool breeze swept around me from the darkness. This fear of the darkness under the pier got me on my feet so fast I don't remember standing, just reaching for the pole. The fish was tired but was still

on the fight as Jose lowered the rod. It was just out of my reach.

"I'm letting go." He let go of the tip of the pole, and it dropped down into my hands. I caught the handle and immediately felt the struggle of the fish on the line.

"Hey, Tim, here he comes the guy with the red shirt!"

The fella had been in the public restroom and was slowly walking up the street, about to enter the pier. He was in no hurry as he slowly made his way up the boards to his spot. I started to reel and before I knew it, Jose had made the jump and was at my side. We headed to the shore, and the fish was just beyond the waves.

"Hey, what you got there, sonny?" We glanced up and quickly our attention went back to the fish. The man's speech was slurred.

"I said, what you got there, sonny?"

It was the man in the red shirt. I was too busy fighting the fish to answer, and besides, I was holding his pole which I thought he would recognize any minute and attempt to land his fish, so I was scared. Jose just ignored him too.

I was glad Jose was with me. I don't think I would have done it alone, but maybe after all that had happened that day, when I think back, maybe I would have.

The man grumbled and sauntered on, tripping and swaying.

"Borracho," Jose whispered in my ear.

"What?" I said

"He's drunk."

We just ignored him as he kept strolling past us to his spot.

"He didn't recognize his pole, but as soon as he finds out where it is, he'll be back," whispered Jose.

The fish fought hard and we found ourselves slowly getting wet. Soon we were up to our knees in the waves as the fish got closer to the shore. There he was, a nice legal halibut moving gracefully through the foam. Waves splashed up to our waist. The pole bent over, the fish ran and I tightened the drag, reeling and pulling back on the rod, the halibut coming closer and closer. I started backing out of the small waves, and soon I was out. Riding a small wave in like a surfer, the halibut was left on the wet sand as the wash receded.

Jose jumped onto the fish and lay down on it, pinning it to the sand, the tail flapping and knocking sand in his face. Soon Jose was covered in sand and slime and laughing the whole time.

"Hey that's my pole. . . dammit to hell!" The drunk fisherman was stumbling back down the pier, stopping just above us.

"And that's my damn fish. . .dammit to hell!" He was leaning over the rail, looking down at us, yelling and cursing.

When I heard this, it literally scared the piss out of

me, but I was so wet, no one—not even Jose—could tell that I was relieving myself in my pants. This made me laugh and shake with fear at the same time.

A wave swept in, covering the halibut and Jose, but he hung on to the fish. We were both soaking wet, but we had the fish.

The drunk old man stumbled down the pier to the street. Then he attempted to hop over the wall, falling and landing on his head in the sand. He was having a very difficult time making his way through the sand to get to us.

"We were just helping you, mister!" yelled Jose.

"You just wait there. . .You just wait there. . .dammit to hell!"

The fish was hooked on the lip. It was about twenty-four inches long and about five pounds.

"Nice fish," I said. Jose and I were both on our knees in wet sand, staring at the beautiful creature.

"Dammit to hell!" We heard the man above the sound of the waves, slowly making his way across the sand to the shoreline. As we turned to watch him fight the sand with every step, a wave came in and we were up to our shins in water.

The fish came to life. Slapping and flopping in the waves, it spit the hook at us and before we could grab it, the tail caught some water and it was gone, back to its home with the receding wave.

I had done it, I had caught a halibut. I was so happy. I was happy for the fish, and I was happy for Jose.

We laughed and the gulls joined us.

"That's my fish, and that's my pole. . .dammit to hell. . .I hate this sand!" He was almost on us, so we jumped to our feet.

I held the pole out to the old drunk. He grabbed it and pulled the line back fast. The sinker and hook shot back like a bullet and hit him in the knee.

"Dammit to hell!" He was hopping around on one leg, the fishing pole in his hands, the hook and sinker tangled around his body. "Where's my fish!"

Jose and I started to run, and we covered the sand as fast as we could. That old fella was angry and drunk, and we were laughing and scared at the same time. We got to the wall and hopped it, looking back at the man in the red shirt, all tangled in his line, rolling around in the small waves and cussing up a storm.

The popcorn man was getting set to close up. He sold popcorn and candy, pinwheels and inflated balloons from an old woody station wagon. We felt a safe distance from the confrontation on the beach, so I reached down into my pocket to get a grip on the coin. My pants were wet and it was difficult. My hand was cold, and I was shaking, but I found the quarter and bought a bag of popcorn. Jose was leaving a big puddle and was shivering really hard.

"You stay away from those bums, you hear me?" The popcorn man was dressed in an apron but had the same hat the halibut fishermen wore. He also had the Pendleton shirt with the sleeves rolled up. He was

a kind man, but he did not like the bums and drunks that lived around the public restrooms. They were always asking him for change or popcorn, and this made him seem grumpy.

"I'm gonna get my bike." Jose tried to run, but the wet clothes and the cold kept his knees from bending as he sloshed his way up the pier, leaving puddles of salt water with every step.

An old station wagon slowly passed by and started the long bumpy drive out onto the wharf. Pigeons started to follow the car, trying to land on top. More and more pigeons flocked just above the old wagon the further up the pier it went. Slowly bouncing over the old planks, the car was covered with more and more pigeons. It was the pigeon man. His old wagon was filled with so much stuff there was only room for him behind the wheel and the huge bag of birdseed he carried in the seat beside him. Every once in a while, a hand would toss seed up onto the roof of the wagon, and the feed would scatter on the car and on the pier. Pigeons knew this car and it wasn't long before the old wagon was covered with flapping wings.

Jose was having difficulty getting on his bike as he pushed it forward and finally hopped on the seat and rode back to pick me up. I stood at the rail, watching the man with the red shirt. He had disentangled himself and was looking for the halibut. I felt embarrassed and ashamed at what I had done. Picking up another man's pole without his permission and landing his

fish was something I will never do again. And losing that halibut will be a memory I will never forget.

Jose came to a sliding stop. "Let's get the hell out of here!"

I folded up the popcorn bag, stuffed it in my shirt, jumped up on the crossbar, and Jose peddled like crazy back out to the safety of the wharf and to our gear. Jose was sopping wet. My pants were soaked as well, but my shirt was still somewhat dry. We were both breathing hard, and the chill of the water and the breeze made us shake and shiver.

We caught up to the pigeon man. The closer we got, the harder it was to see past the hundreds of birds covering the car. We started to pass and were sprayed by seed and cracked corn as we came up beside the old wagon. The pigeon man gave us a nod. He was smiling through big rosy cheeks, and his eyes were kind.

"Hello, boys." This man looked just like Santa Claus. He had a huge white beard and long white hair.

"Here we go babies, here we are," he said, and would throw a handful of seed.

His car was covered with birds and piles of bird poop almost an inch thick on the roof. Jose peddled as fast as he could, and we slowly passed the wagon and headed for the crab shack.

We arrived at the crab shack and I jumped off. I stood next to the big boiling pot and warmed my hands on the bricks that lined it. Jose was so cold and

wet he had difficulty parking his bike, and it fell over. He just let the bike lay against the shack and joined me at the pot. Putting our hands on the bricks, then turning and putting our backs and butts against them made our butts steam and was pretty funny until the crab man saw us and told us it was dangerous and to stand back.

We ran around the corner of the shack. The old black man, his stool tipped back, was leaning up against the shack, taking a snooze. Our gear was right where we left it.

"Sure am cold," said Jose. We were out of the wind but we were freezing, so we lay on the hot wood planks and looked out at the harbor mouth and the late afternoon sky. I pulled out the bag of popcorn and placed it between us. We filled our mouths with the buttered popcorn. Pieces that fell through the cracks were nibbled at by small fish. The breeze let up and the colors in the sky started to grow warm with yellows and light orange on the western horizon.

"That was the first halibut I ever touched," said Jose. His voice was shivering, but he was happy and smiling.

The old wood planks had baked all day and radiated heat right through our wet jeans to our skin.

"That was the first halibut I ever caught," I answered.

The sun was about an hour from setting. The only clouds were on the horizon, and the reflection off the

now-glassy sea gave the same sensation as that of sitting before a campfire. We were warming up and the day was coming to an end.

As we both lay on the pier, facing the west and staring towards the horizon, the shivers and shaking stopped. The pelicans circled and dove just beyond the harbor mouth. Small groups of gulls left the pier, and when a pelican dove into the sea, a gull would quickly set beside it, looking for bits of fish that may have been missed.

We poked our heads over the rail and looked down into the clear water. Schools of smelt and small perch darted in and out of the shadows. I was all fished out, and so was Jose. But I still had half a sardine in my tackle box and thought feeding the fish would be fun.

"Just a minute."

"Where you going?"

"Be right back." I jumped up and went to my tackle box, opened it and grabbed what was left of the sardine I had used for bait. And there was my mackerel, all dried and shriveled. It was so small now compared to the fish I had seen today, the thought passed through my mind to feed it to the fish as well. But it was my first mackerel, and it was all I had to show for a full day on the pier, so I decided to keep it and show my mom. Closing the box, I grabbed my sweatshirt. It was extra-large on me so it would fit my friend.

"Here put this on. It's dry."

"Gee, thanks. I'm really soaked," Jose said as he took off his wet shirt and changed into my hooded sweatshirt. "I jumped on that halibut, and then that wave came in, but I held on!" We both laughed.

We sat next to each other and pulled off little pieces of sardine, dropping them into the sea.

"Look at that one," I said.

A small calico bass suddenly appeared and ate the chum. The more bait we threw into the sea, the more fish showed up. This was almost more fun than catching a fish. Pretty soon we had several dozen fish just looking up at us, and we just stared back, throwing bits of sardine until all that was left was the skeleton.

"Here goes," I said and threw in the remains. As the last of the sardine sank, all the fish crowded onto the bones that were slowly sinking to the bottom where the crabs would also get a meal.

The old black man awoke. "Well, you boys was gone for a while. I think I be heading home." He dumped the remaining mussels from his sack into the sea. Then he stood and picked up his stool and bucket of perch, his pole and box and set them in a grocery cart that had been next to the garbage cans.

"I'll see you boys later." Then he stopped, looking down at me. "Now don't go showing nobody my set-up."

"I promise," I said and he made his way down the pier towards town.

"I think I'll be heading home too." Jose was still

shivering but smiling.

"Don't you want to wait for the boats to come in?" I asked.

"Nah, I'm cold. I think I'm gonna go. . . .See you tomorrow?"

"Oh sure. I'll see you tomorrow. . . .You can give me my sweatshirt when I see ya."

"Thanks," he said and got up and tied his pole and box to his bike. "Adios." He snapped his finger and gave me the thumbs up and I did the same.

"Adios," I said, and I watched him leave. . . .

The sun was still warm in the late afternoon and my long-sleeved shirt was dry, but my pants were still damp. I was pretty tired, so I just sat there looking out to sea and the changing colors on the horizon. The wind had stopped, and the ocean was glass as an explosion of breath and motion appeared just below me. It was a huge sea lion and all his attention was focused under the pier. He looked up at me and then back under me and down into the pilings. Slapping the surface with his fin, he stayed focused on something. I made a move to have a look, and my movement caught the big seal's eye and he dove and swam up the outside edge of the pier, only to surface and slap his flipper again—smack, smack, smack—and he was gone.

I heard something under the pier that sounded like voices, but it was hard to tell with all the other sounds. There was a ladder and a small catwalk behind the restaurant that was just down from the crab shack. Now, I had promised my mom that I would not go under the pier, but I thought that meant only on the beach part. That's where the bums slept during the heat of the day or when it rained. And it was the bums she worried about.

There was a commotion over by the landing, and I stood up and walked around the crab pot to see, still intrigued by the sounds under the pier. The word was out that the bonito were in and the evening bite was warming up. Men left work early to catch the run. Several men with huge surf-casting rods were hooking up and a crowd was gathering.

These poles were about 12 feet long with big reels and 30 to 50 pound test line. These fellows had bonito feathers, big shiny sinkers, spoons and bones on, and were casting 200 feet out and into the boils

near the anchorage.

"Hook up!" they'd shout, and the big poles would bend and the big fish would fight.

"Horse him in!"

Some of the line was just too strong and bonito as large as 10 pounds were hauled in. The smaller ones came in so fast they skimmed across the surface. Several poles had hookups, and the laughter and activity drew a crowd.

I was amazed by the power of the casts and the strength it took to throw the lures so far.

"Look out, kid." The man had on a white t-shirt and his arms were covered with tattoos.

I backed up at the swish of the pole and hiss of the line as the big lure sailed almost to the little sailboat where the big halibut had lay digesting my little mackerel.

As soon as the lure hit the water, he started to reel fast. Water from the splash of the lure was still in the air when he yelled, "Hook up! Crank him in!" The big pole bent and the line cut the water like a razor.

I moved closer to the edge of the pier to get a look. A radio was on the hood of a car and turned up loud, and the men kept a beat to the drums and guitars as they laughed and fought the big boneheads. His pole bent over, the fish started to peel out line.

"What the. . ." The big sea lion surfaced and the bonito was in his mouth.

"Say goodbye to that one!" That big seal whipped

the bonito like a puppy with a rag.

"Let go of my fish!" he cried and the sea lion dove, the line peeled, and then the pole went stiff. He reeled as fast as he could.

"That's my lucky lure. I hope it's still on." As he cranked, the pole bent slightly. Laughter came from his friends as he brought it to the surface and up to the pier.

"Bonehead! You got a bonehead!"

Even he had to laugh. His lure was still on and hooked to just the head of the big bonito. The big sea lion surfaced and threw the remains of the fish into the air.

One of the sport boats was approaching and with the sea lion eating his prize, any fish in the area scattered and the hookups slowed. I was still curious about the voices I thought I had heard and wandered back to the ladder that dropped down under the pier. Putting my ear to a crack near the ladder I thought I could hear something— voices, whispering.

With all the attention focused on the guys with the big poles and the approaching boat, no one was watching as I made my way to the ladder and crawled down over the edge. Looking through the rungs of the ladder into the forest of pilings, I had to wait a second or two to build up my courage to continue. And with the light changing from the surface of the pier to under the planks, it took a minute for my eyes to adjust to the darkness.

A catwalk serviced the pipes that went from one side of the pier to the other. I was just above the widest part of the wharf, so it was a good distance across and out into the open sea. With so many pilings, it was hard to see the blue on the other side. Only two planks, side by side, each plank was about twelve inches wide.

I lowered myself to the catwalk and immediately got on my hands and knees. I was not going to attempt to walk. The ladder continued down to the surface and the tide was high, so if I was to fall, I thought I could swim to the lowest rung and pull myself up.

I had heard stories of kids falling off the pier, and there were life rings up above, but no one knew I was there and no one would be able to hear my calls if I did fall in. So I stayed on my hands and knees and crawled very slowly.

The voices became clearer the further I crawled under the pier. The loud whispers and the sound of the chop from the slow swells against the pilings captivated my curiosity. I heard talking—it was just ahead so I continued. Pigeons on nests and roosting made cooing sounds and some flushed, wings slapping. I heard a conversation from people passing overhead. I had to stay focused; it was a long fall to the sea.

Directly down from me and still unseen, I heard, "I turned around and he was in my face. . .it scared the hell out of me. What was I supposed to do? I

didn't expect no sea lion to grab my bag!"

"Damn it, Jerry, I thought you said no one would see us. How did they find out?"

The light from a small crack above helped me make out two dark figures. These were the divers the Fish and Game officers must have been talking about. Their heads were just above the surface. The wetsuit hoods were as black as night and the face plates and snorkels were all that was visible. It would be hard for Fish and Game to catch these guys.

In and out of the light as the late afternoon sun found the cracks in the planks, the moving sea made a very scary place especially in the water.

Footsteps and cars overhead and the flapping of pigeons added to the atmosphere of excitement.

"There they are, over there! Just be quiet now. . .that seal is gone."

"Look. . .they got the tube, so they know we're here. We just wait till dark and then we can make it to the boat."

I kept still and quiet. This was really cool. I could make out the small dingy with the Fish and Game officers and the beam of a flashlight, but it was a good distance from the divers.

The familiar sound of the sport boats' engines approaching drowned out all the sounds from above. The big hull was visible as it motored along the pier and made its approach to the landing. The wash from the wake of the boat created small waves under the

pier and the divers' heads disappeared in the chop.

The increase of wave activity gave me a shiver up my back, so I started to crawl in reverse. I better leave; it was getting late and it was probably close to the time I said I would meet my mom.

I backed up without turning until I felt the ladder with my foot, then very slowly turned and scrambled up the ladder and onto the pier. *Wow, that was a thrill!*

The boat was tied and fishermen were unloading. The next boat was coming in too. Gulls hovered above the stern as the remains of filleted fish were tossed overboard. I could see the Fish and Game officers checking licenses and limits of fishermen as they made their way up the landing.

Should I tell them what I saw? I went to the edge to look down onto the deck of the boat. Big fish littered the deck, and large forked tails seemed to fill every bag. Several big fish were in the bait tank.

"We killed 'em," I heard one fella say.

"Everybody got limits," said another. Yellowtail. Every bag on every shoulder was full of big yellowtail. Over the loud speaker came "Jackpot was a 40-pound yellowtail caught by Gene Bottoms. Got to watch those Bottoms boys, folks."

The same group of kids was there asking to see the fish and if there was any fish anybody wanted to give away. I was close to the Fish and Game officer and was about to tell him what I saw when I heard a fisherman say, "Sure, here kid," and handed one of

the kids a big bonito. The thought of telling the officer just evaporated from my mind when the man put the big bonito in the kid's hand. I thought I could do the same, ask for a fish, but I just couldn't get close enough to the gangplank.

"It's about 5:30," I heard from the crowd. Oh boy, was I late! My mom would be worried, so I ran back behind the shack and grabbed my pole and box. I was really torn—should I go over and ask if anyone wanted to give me a fish? All I had was a mackerel that at the time seemed so big but had gotten very small after seeing all the big fish today. Should I tell the Fish and Game what I saw under the wharf? If I did, would they tell my mom I was under the pier? Would I get in trouble? Probably.

No, I was late, so I started to run and then slowed to a walk to the boulevard. I was so tired. The day caught up with me, and I was really dragging along. My sneakers were wet and untied, but I was too tired to stop and tie them. My pants were still wet too, and I felt like I was starting to get a rash from the denim. I

was just watching the cracks and feeling pretty sorry for myself because I had seen so many big fish, and had even caught a nice halibut, but all I had to show for it was a mackerel.

I guess I wasn't watching where I was going because I walked right into a bag of fish. A man had set it down to open his trunk. He was an older man and had been out on the boat. I stumbled but didn't fall and was staring at the big tails sticking out of the sack.

"Hey there, fisherman, any luck?" he said as he pulled his head out of the trunk.

"Oh, I'm sorry, mister. I guess I wasn't watching where I was going."

"Have any luck today? Catch anything?" he asked.

My mouth opened, but I didn't know what to say. So much had happened today. I didn't know where to begin. Then a flood of sadness just came over me. I felt like crying, but I held it in and said, "Kind of."

"Let me show you something," he said as he opened the sack and removed a big yellowtail. "What do you think?" The fish was about three feet long and about 25 pounds. It was a beautiful white silver with a yellow forked tail and yellow fins.

I couldn't speak, it was a beautiful fish, but I had seen so many beautiful fish that day. "Nice fish," was all I could say. A lump was growing in my throat.

"Listen, I was lucky today, and I don't really like to eat fish. I give 'em to my friends and neighbors. Would you like one?"

I couldn't believe it. A fisherman who didn't like to eat fish? And he wanted to give me one of his? I didn't ask for a fish. Here was this nice man wanting to give one of his.

"Uh. . .sure. . .thank you, mister." I kneeled down and put my hand on the big fish.

It was cool and smooth.

He kneeled down and looked at me; his eyes were clear as he just stared at me. I felt embarrassed. I didn't know what to say or how to react.

"God loves you, son." We just stared at each other and then at the fish.

"Ok." I whispered as I stroked the big fish with my hand.

"Can you handle it?"

"Oh, yes, sir, I sure can."

He stood and put the large sack of fish in his trunk. I just knelt there next to the fish. He started his car and backing up, rolled down the window and stopped. He stared at me again, smiling. I smiled right back. I could not believe how lucky I was and how good I felt.

"God bless you, boy." Then he put it in gear and drove away.

"Thank you," I said. He waved a hand out the window, I waved back to the stranger. "Adios!" I yelled. Even though I didn't know the translation from Spanish to English, it seemed fitting.

The sun was on the horizon, and clouds like full sails from a fleet of ships were filled with rays of red and orange. The big fish lay beside and behind me and radiated in the last light of the day. Gulls and pelicans began their migration to the sandbar at the harbor mouth. Birds were coming in from all directions, looking for their families and the safety of the sandbar for the night. The foothills were a brilliant purple and blue-green like the sea.

I tied my sneakers, slipped my hand into the gills of the big yellowtail, my pole and box in the other, and a surge of energy filled me. I began to walk as the big tail slipped and slapped along the planks behind me.

Fishermen in their cars heading home would wave or give me a thumbs up. I would nod back with that *I-got-mine* kind of nod, because my hands were full, a pole and box in one hand and a big old tail in the other.

"Nice fish, kid," a man passing commented.

"You can say that again," I answered without stopping.

"Nice fish," he repeated as he continued, and we

both laughed. I was floating on air. What a day. Just like that, everything changed.

As I passed The Shell Ship, the lady was locking up. She just stared as I trudged by. I looked at her and looked at my fish and cocked my head to one side, focused, like I meant business, and kept right on walking.

Everyone I passed stopped and stared or asked, "What kind of fish is that?" or "Did you catch that on the pier?"

I just kept walking and would give 'em that *Maybe-I'll-tell-you-or-maybe-I-won't* kind of look.

I could see the boulevard now—not far to go. I stopped for a rest, needed a breather and to change hands.

I wasn't far from where I saw the halibut fishermen that morning and where I grabbed the pole that belonged to the man with the red shirt. I looked towards the harbor and the sunset. The glassy sea was on fire with the same colors as the sky. Pinks and reds covered the whole dome of the universe. I felt so alive. I could feel my heart beating and the blood rushing to my head. I screamed "Yessss!"

Lights of the city were starting to come on, and I could hear the sound of the courthouse clock—six o'clock. Boy, was I late. Picking up my load and taking a deep breath, I began to run, the big fish flopping behind me. I flew towards the beach, feeling weightless.

There was the wagon parked near the palms. My

mom and dad and my two brothers were on the sand watching the sun set.

"There he is," I heard my dad say. "We were starting to worry about you."

"What the heck you got there?"

I yelled, "Yellowtail!" My dad was in a coat and tie—his work clothes.

When I got to the car, I felt light and dizzy. He looked down at the big fish. And then he looked me square in the eye. I suddenly felt pretty nervous.

"No tall tales now. Where did you get it?"

"I didn't ask for it. A man just asked me if I wanted it." It sounded like a fib, but it was the truth.

"Nice fish, nice yellowtail," is all he said.

"I told you five o'clock—you're late. But it's ok," said my mom. She had Sam in her arms and was holding Joe's hand with the other. Joe just looked at the huge fish, his eyes as big as silver dollars.

"Any spare change or fish you don't want?" It was the big man in the floppy hat. He was sitting in the shadows of the palm grotto.

"I'll put the kids in the car," said my mom, and she opened the door and set Sam on the seat and helped Joe into the back.

My dad put his hand in his pocket, and I heard the familiar jingle of change, and so did the bum. He stood as best he could, almost falling down. My dad walked over to him, and as he did the big man removed his hat and, looking down at his old

boots, put out his hand. My dad put some change in his hand.

"Here you go, old timer."

The big man just kept his head down, looking at the change.

"God bless you, sir."

"Wait a minute," I said and kneeled to open my tackle box. I took out my mackerel. I walked over to the big man and held out my fish.

"I cleaned it myself, scraped out the blood along the back bone too."

He put the change in his pocket, and I put the mackerel in his big hand.

"I love mackerel. God bless you. God bless you, sonny." A big smile crossed his face.

I can't explain it, but that sure made me feel good, and I felt a big smile just slowly grow from cheek to cheek. My dad was smiling too as we strolled back to the wagon.

"I'm proud of you, son. Now where are we going to put that big old smelly fish? I don't want it to smell up the car."

From behind us, the old hobo said, "I got something for you, fellers." He stumbled into the grotto and returned with some of the cardboard and old newspapers he used for his bed.

"Will this suffice?" he asked.

"Yes, that will do nicely," my dad answered. Opening the trunk, we laid the paper and cardboard down,

then the fish.

"You smell pretty ripe too. Why don't you hop in there next to your fish?"

"No problem," I said, and I did.

As we drove the palm-lined boulevard, leaving the pier behind, the big man, haloed under a street light, waved with one hand and held up my mackerel with the other. Pointing to it, he gave me a thumbs up.

I gave him a snap and a thumbs up. "Adios," I whispered.

THE END

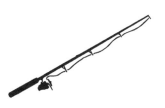

IN MEMORY OF MY MENTORS AND HEROES

My Grandfather William "Bill" Bottoms

My Father James "Bud" Bottoms

His fishing and hunting buddies,
Jimmy McCaffrey, Dale Howell,
Gene Camby, and Mike Moropoulos

My Father-in-Law Jack Morehart,
with whom I fished on his yacht, *Ranger*

And my dear old friend Richard "Dick" Shea, DVM

And my friend Jose.
Tragically killed by a car riding his bike on Milpas Street. In my mind he had his fishing pole and tackle box with him and was on his way to meet me on the pier.

Vaya con dios, mis amigos.

ACKNOWLEDGMENTS

In spring of 2007, Marcia Morehart, my friend and mother of three of my children, encouraged me to write a story. So, I placed my little portable Olivetti typewriter before me, loaded a blank sheet of paper, and stared at it for hours; until the story from my memory and imagination moved through my fingers onto the page. Three days and nights later *The Pier* was born.

The world was changing, life unfolding. Decided to stop swimming upstream so drifted with the flow.

2020 Brenda Zucchini helped resuscitate the story of a eight year old boy, spending a day fishing on a pier.

Shared my little tale of a tail with old friend Gail Knight Steinbeck. I first met Gail with her husband, Thom, at his father's library in Salinas, California. My brother, Sam, and I were invited to read excerpts from John Steinbeck's novel *To A God Unknown*. Gail agreed to give it a read; and suggested Editor, Maureen Phillips, in Vancouver, BC, who graciously helped with the first edit. Gail did the second. Brenda and I the third go around, reading aloud.

The amazing and talented John Balkwill of Lumino Press in Santa Barbara, California designed the complete layout of *The Pier*.

Thank you everyone. From the bottom of my heart.

This little adventure is going out into the world.

TJB

CPSIA information can be obtained
at www.ICGtesting.com
Printed in the USA
BVHW040946180423
662567BV00004B/40